A TO Z OF
PHOTOGRAPHY

*a journey through selected topics that
shaped the photographic world*

Mike J. Smith

Cover design by: Kafi Ahmad
Alphabet Typeface: Procrastinating Pixie

INTRODUCTION

We all like to collate, classify, and generally create order out of the world and it's no different with photography; so was born the idea for an A to Z of Photography. In starting a project like this, I'm reminded of an episode of Blackadder (Ink and Incapability) in which he meets Samuel Johnson who is compiling a dictionary of the English language. Blackadder responds to the introduction by saying "I hope you will not object if I also offer the Doctor my most enthusiastic contrafibularities", at which point the doctor begins writing furiously.

Almost by definition, we can't know everything and so it would be foolish to even attempt to write a comprehensive encyclopaedia. However, I have an innate desire to know a little more about all things photographic, so to have created a small book that provides more than a few cursory words on a topic is a joyful thing. Think of it more like a curated monthly magazine that you can linger over if you choose.

As a result, the expectation from the beginning was more pragmatic — this A to Z is intended for you to dip in to with your morning coffee, whilst commuting to work, or during a lunchbreak. Each letter of the alphabet is organised around two broad areas: *content* and *creation*. The first will generally cover photographers, books, photos, and places. The second will look at manufacturers, gear, and techniques. There is no specific rationale for a subject's inclusion other than I think it's interesting!

The idea is that this A to Z becomes more than the sum of its parts. Yes, it is intended that you can read through, consume, absorb, and hopefully learn something new, however you will also see different themes weave their way through the topics

covered. I hope this will provide a touch paper to fire your own connections between the articles and then go on to explore either these — or new — topics for yourself.

Mike Smith

MANUEL ALVAREZ-BRAVO (1902-2002)

If there is one adage in life then it's not what you know, but who you know. There are a ton of photographers out there who have a lucky break and base their entire career on it (such as Robert Davidson's famous Zappa Krappa). It's when you are both talented and know people that the magic happens, which it did for Manuel Alvarez Bravo.

Born and raised in Mexico City, Alvarez-Bravo trained as an artist before turning to photography. By 1930 he replaced Tina Modotti at the magazine *Mexican Folkways*. That would be the same Tina Modotti who worked closely with, and was a lover of, one Edward Weston. During this period, he took pictures of artists Diego Rivera and José Clemente Orozco. He also met, and exhibited with, Paul Strand, Henri Cartier-Bresson, and Walker Evans. One of their contemporaries, he formed part of the North American upwelling of photographic talent that stormed their way to the post-war world of the 1950s.

Now known for his nudes, *Good Reputation Sleeping* is a delicate example of long forgotten hot summers. Yet simmering beneath the surface is an artist exploring the same trope that Weston, Steiglitz, and Strand did — the female nude. Whilst seemingly innocent, there is a visual discontinuity that plays against the traditional Mexican architecture and athletic subject. That discontinuity is the clothing. To me, the bandages are reminiscent of Milla Jovovich's Jean-Paul Gaultier clad character, Leeloo, in the *Fifth Element*. Through contemporary western eyes, the bondage-clad inferences make the image sex-

ualized. Whether that was the intent of Alvarez-Bravo remains to be seen, however the lack of underwear reveals her pubic hair which would have been provocative. By being both partially clad and distant, the image is able to keep asking questions without being explicit. Perhaps those that followed, such as Nobuyoshi Araki and Robert Mapplethorpe, continued the same exploration, yet their images continue to shock to this day.

Alvarez-Bravo was, of course, known for more than just nudes, depicting cultural change after the Mexican revolution. His work naturally touched upon the theme of identity and the impact of historical cultural themes, such as myth, literature, and music. In some senses he might be thought of as a street photographer as he covered the everyday interactions of people. He tried to transcend stereotypes whilst being artistic, yet at the same time not descending into the picturesque. Although not political he didn't shy away from difficult subjects, including aspects of death such as 'Striking Worker, Assassinated' and 'Portrait of the Eternal'.

APERTURE

The camera is ultimately a simple device. This is exemplified through the pinhole design of the camera obscura where all you need is a hole through which you can project an image onto a screen. The size of the hole (aperture) and distance to the screen (focal length) give some control over the image.

In contemporary camera design a variable size aperture — or diaphragm — provides the greatest flexibility. Usually integrated into the lens, increasing or decreasing its size causes a change to the overall quantity of light that passes through. The f-number (N) is a measure of lens speed, calculated as

$$N = f/D$$

where f is the lens focal length and D is aperture diameter. Clicked aperture settings are designed to double or halve this value allowing control of the total exposure value.

Crucially, increasing the size of the aperture decreases the depth of field that is considered acceptably in focus. An increase in the distance to the subject, decrease in aperture size, and decrease in focal length all lead to a larger depth of field. This change is linear for the f-number, but proportional to the square of the focal length or the distance to subject. That means, if you decrease your focal length or move further away from your subject you will more rapidly increase your depth of field at no expense to exposure, but with a wider field of view. As with anything optical, there is always a trade-off between options!

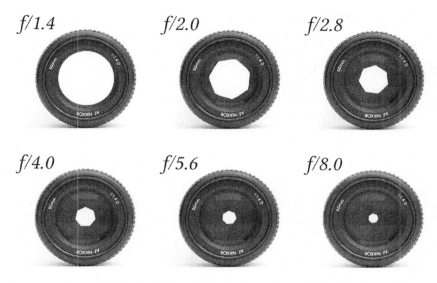

Image courtesy of KeoppiK via Wikipedia (tinyurl.com/y5ax8bj3)

* * *

Beyond The Cut

Other As that didn't make the cut include Richard Avedon, Eugène Atget, Ansel Adams, the Airy disk, architectural photography, Arri, and Agfa.

MIKE J. SMITH

B

BRONICA

Bronica, or Zenza Bronica, is a household name for scores of photographers across the world of a certain age, from budding undergraduate students through to hardened professional wedding togs. If you couldn't afford a Hasselblad then Bronica was your go-to brand. Founded in 1956 by Zenzaburō Yoshino, the company was driven by his passion for foreign film cameras from the likes of Leica and Rollei, and his desire to produce an interchangeable single lens reflex medium format model that improved upon them. With the first prototype produced in 1956, the model Z (later the D) was released at the Philadelphia Camera Show in 1959 to great acclaim. Initially they used Nikkor lenses, before setting up their own optical unit.

Like the Hasselblads from which they took much of their inspiration, Bronicas had a modular design consisting of the body, lens, film back, and viewfinder allowing flexibility in configuring a camera for the job at hand. The 'Classic' series were 6x6cm SLR medium format cameras with a focal plane shutter. In the 1970s Bronica split the system in two with the compact 6x4.5cm ETR series which used their own lenses employing leaf shutters. The traditional 6x6cm SQ series continued the Classic line, again with Bronica's own leaf shutter lenses.

Tamron acquired Bronica in 1998 before the introduction of the Bronica branded RF645 ultra-compact 6x4.5cm medium format rangefinder which was to be their last camera, discontinued in 2005. For film aficionados the RF645 and Mamiya 6 offer highly flexible medium format cameras in a svelte design. It was for this reason that I bought an RF645 which is a joy

to shoot with and produces excellent results. RIP Bronica in the graveyard of companies that produced great products but didn't manage to join the digital party.

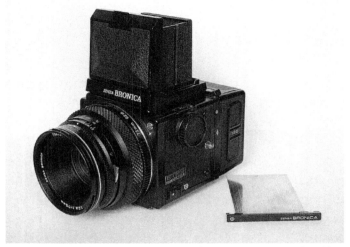

Body image courtesy of Ghostavny via flickr (tinyurl.com/y3orbcwb)

EDWARD BURTYNSKY

Canadian photographer Edward Burtynsky is of Ukrainian descent most famous for his highly detailed, grand sweeping vistas of industrial and post-industrial landscapes. In his own words:

[the] imagery explores the collective impact we as a species are having on the surface of the planet; an inspection of the human systems we've imposed onto natural landscapes

Having taken inspiration in his formative years from Ansel Adams and Henri Cartier-Bresson, Burtynsky has described his work as 'The Contemplated Moment.' Obviously in contrast to Cartier-Bresson's 'Decisive Moment, it perhaps well exemplifies the difference between street and landscape photography. The former capturing the dynamic elements of daily life in visually serendipitous arrangements, whilst the latter is about a set scene, no less beautiful, but one that can be viewed contemplatively at length. This plays to Burtynsky's style of hyper-real, hyper-detailed, images.

How detailed are we talking about? Much of his work has been shot on half-plate (4x5") and full plate (8x10") sheet film using a field camera. Prints are large ranging from 18×22 inches to 60×80 inches. Why shoot film and large format at that? Simply because the detail in a negative is insanely good. If we are being optimistic at going for 150 line pairs per millimetre, then a 4x5" frame is notionally equivalent to 1026 megapixels. His analogue workflow involved taking 10s to 100s of photos of a subject using different films before eventually printing them on different papers to hone the result. Since 2010 Burtynsky has

been digital, shooting exclusively on a Hasselblad using 60MP and 100MP backs. Whilst the resolution might not be equivalent, the 16-bit raw files and print size means he believes the results are better.

Of course, images aren't just defined by megapixels and whilst detail is an aspect of Burtynsky's style, his method clearly produces something that is more than the elements it is composed of. That is no better exemplified that through his use of elevated vantage points that produce grand sweeping vistas, such as with his work on the *Anthropocene* demonstrating the impact of the human race on their environment. Burtynsky's work is therefore immersive highlighting the scale of the impact we have had on the environment. As a result of the powerful impact of his work, Burtynsky has received numerous awards including from the Geological Society of America, TED, and Photo London to name a few along with a number of honorary doctorates.

* * *

Beyond The Cut

Other Bs that didn't make the cut include Bill Brandt, Brassai, bromide, David Bailey, Roland Barthes, Cecil Beaton, Jane Bown, John Berger, black and white, blur, Margaret Bourke-White, Mathew Brady, Bromoil, and Rene Burri.

CENTRAL PARK

By dint of being photographers it means we end up photographing people, objects, and places. It's what we do. Naturally, then, there are places we want to photograph. In fact travel photography — in the form of photographing places we have visited — has a history as long as the camera with early work from the Abdullah Freres, John Thomson, and Francis Frith being good examples.

In the social media age where it is not so much *what* you take a photo of but rather *where* you are and how that importance is translated to the individual — the selfie reigns supreme. For many, that will mean a bucket list with some popular spots including Taft Point (Yosemite), Antelope Canyon, and Maya Bay (Thailand). In short, everyone is a photographer because they have a smartphone and want to take a selfie! Where then is the most photographed place on the planet? It has to be where people want to take photos, that they have a camera, and, well, there are a lot of people!

How you exactly count photos, and recognize where they are taken, is open to debate. In this instance Google was my friend in sourcing different top ten lists and, unsurprisingly, they are almost entirely comprised of cities. Expedia used travel photography website Trover which gave the top spot to Central Park in New York City. In contrast, Conde Nest Traveller based their count on Instagram with the Eiffel Tower garnering over 4.5M posts since 2013. The Readers' Digest also used Instagram and reckon New York City was the most photographed in 2017.

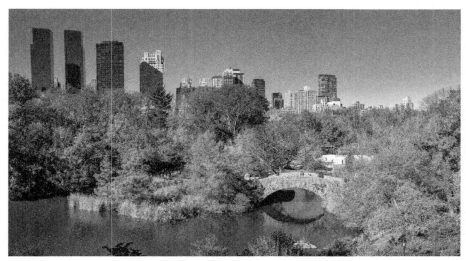

Image courtesy 12019 via Pixabay (tinyurl.com/yxuq7fuc)

The Washington Post went for Panoramio instead and, surprise, surprise, New York City remains the most photographed, with the Solomon R. Guggenheim Museum taking top spot for location. The last word naturally has to go to Quora and roundly trumps all of the above lists. Yes, the most photographed place on Instagram for 2017, following reporting in The Telegraph, is Disneyland, Anaheim.

What does the above show? If you want to stand out and rise above the graphical noise that is visually stupefying us, then go somewhere that isn't on that list. That, or be so astronomically off-the-scale in your work that people sit up and listen... or rather look!

LEWIS CARROLL

It's an overwhelming mystery, wrapped up in a fairy tale, that might be a nightmare. The life of Charles Lutwidge Dodgson takes some telling and has been the source of active documentation and controversy for nearly a century. Better known through his pen name Lewis Carroll, Dodgson is remembered for writing Alice's Adventures in Wonderland and Through the Looking-Glass, along with noted poetic literary nonsense Jabberwocky and The Hunting of the Snark. Educated at the University of Oxford (Christ Church) he was awarded a First Honours in Mathematics before going on to teach mathematics at the university. Following family expectation, he was ordained a deacon in the Church of England in 1861. His scholastic achievement reflected his generally high ability and he also wrote (rather well!), painted, and invented. As a university teacher, he wrote a number of academic manuscripts which have remained current and relevant, outlining the sophistication of his research in areas such as geometry, algebra, and logic, including writing nearly a dozen books. He was an avid writer of letters and even authored 'Eight or Nine Wise Words About Letter-Writing'. As an inventor, he devised a postage stamp case (for Wonderland stamps!), a nyctograph for writing in the dark, and even an early form of Scrabble. Surprisingly, and unknowingly for me, he was also a photographer of note.

Dodgson attended Oxford in 1851, working as a teacher from 1855. This almost exactly coincided with the collodion wet plate process and during this period he mastered the technique, creating over 3000 plates and even had a studio of his own. His work was well received and his portraiture extended to celeb-

rities including John Everett Millais, Ellen Terry, Dante Gabriel Rossetti, Julia Margaret Cameron, Michael Faraday, Lord Salisbury, and Alfred Tennyson. After a 24-year career, he abruptly stopped plate making in 1880, in part due to the popularity of the dry-plate process (which allowed other photographers to work more quickly) and changing tastes.

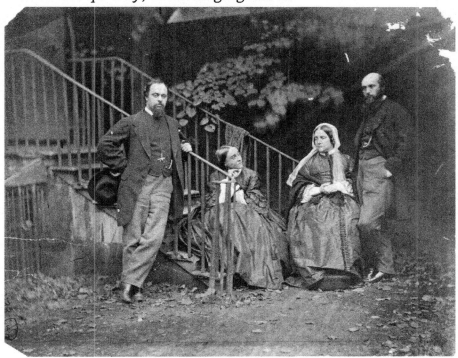

Image in the public domain, via Wikipedia (tinyurl.com/y53hfkaz)

Of the 3000 plates, only about 1000 survive. This is partly due to the fragile nature of the medium, but also because many of them were destroyed either by Dodgson or those that inherited them. This leads to the most controversial aspect of his work — he clearly liked photographing children. Around a half of the surviving images are of children, thirty of which are nude or semi-nude. Whilst questions about his sexuality didn't arise until the 1930s, well after his death, the topic remains controversial. Of early photographers, he wasn't alone in photo-

graphing children and we can't ever fully understand Victorian sensibilities with regard to photography. In essence, we are appraising 1850s photographers within our own social context, yet it remains that he was a bachelor who spent periods of time entertaining young girls and (professionally) photographing them, sometimes naked. The Smithsonian Magazine gives a good appraisal of current thinking, whilst the BBCs recent documentary has more forthright views expressed.

Looking beyond this controversial aspect of his work, Dodgson clearly takes his place as a photographer of significance during the formative years of photography as an artform.

<p style="text-align:center">❉ ❉ ❉</p>

Beyond The Cut

Other Cs that didn't make the cut include the Calotype, childhood photos, Canon, Cprint, Julia Margaret Cameron, Robert Capa, carte-de-visite, Henri Cartier-Bresson, Cibachrome, Larry Clark, Cosina, Cliche-verre, Chuck Close, collodion process, contact print, copyright, and Imogen Cunningham.

DAGUERROTYPE

The Daguerrotype was announced in August 1839, being gifted to the world patent-free by the French government. Developed by Louis Daguerre, with a significant dose of help from Nicéphore Niépce, it enabled cameras to produce permanent images. Niépce developed the chemistry to produce photographs, although they required very long exposure times. Daguerre improved the process by using iodized silvered plates that were subsequently developed with mercury fumes, integrating the plates into a camera and calling it the Daguerrotype.

The photographer needed a polished sheet of silver-plated copper, treated it with fumes, making it light sensitive, before exposing it in a camera. Mercury vapor was then used to develop the image, before fixing. After rinsing and drying, the plate was usually sealed behind glass. The resulting positives were highly detailed, but lacked any method for easy reproduction. This was in contrast to the Calotype, announced in 1841 by William Fox Talbot, which used light-sensitive paper (silver iodide coated) that produced a translucent negative. This allowed reproduction through contact printing, but the images were less detailed.

Daguerreotypes normally produce an image that is laterally reversed (i.e. mirror images) due to the lens. This is true of any optical instrument and is easily corrected by placing a second lens in the system; however, it appears this was not regularly performed because of light loss which consequently extended exposure times. For translucent negatives, you can just flip the image, but this was not possible with Daguerrotypes. If there is any reversed writing in an image, then this is why! Daguerro-

types also provide a different viewing experience to contemporary photographs, because the image sits beneath the surface of the glass cover and almost appear to float. In addition, the viewing angle can also cause the image to flip from positive to negative (and back), all of which produces an immersive experience.

The Daguerrotype rapidly spread around the world, reaching the U.S.A. by 1840, Australia by 1841 and Japan in 1857. By 1853, somewhere in the region of three million plates were being manufactured in the United States alone. The sheer scale and openness of the invention led to a whirlwind of innovation. Of particular importance were improvements to the chemistry by switching the sensitizing agent from iodine to bromine or chlorine (I'm guessing health and safety was fairly rudimentary!), which dramatically increased the sensitivity of the plates, thus reducing exposure time. The other key improvement was to the lens, with the release of the Petzval Portrait Lens. Up to this point, most photographs were restricted to landscapes and architecture simply because of the long exposure times. By improving the design, Petzval produced an f/3.6 lens, in contrast to the previous f/14 Chevalier.

By 1860, the Daguerrotype had all but died out. The wet-collodion process largely replaced it, as it solved the two key limitations of the daguerreotype. Firstly, it produced a negative, allowing image reproduction and, secondly, removed the quality constraints of paper introduced by the Calotype. Photography, for the first time, had both quality and reproduction. Since then, the Daguerrotype has only seen special interest use.

Image courtesy Wikipedia, in the Public Domain (tinyurl.com/y5n3c8v6)

FREDERICK DOUGLASS

He wasn't a photographer, by Frederick Douglass takes an auspicious place in American history. Born in 1818 to slavery, he was a staunch abolitionist, as well as an orator, writer, and politician. An intellectual, he wrote several books, speaking and campaigning extensively against slavery.

What is striking about Douglass is his progressive liberal ideology within a young nation, along with an acute ability to convey it. His views, perhaps surprisingly, remain contemporary. He believed in equality of all people, regardless of gender or ethnicity, while progressing this agenda by creating dialogue between different racial and political groups. He was criticized for entering into discussion to resolve differences and his response was a pragmatic one:

> *I would unite with anybody to do right and with nobody to do wrong.*

Douglass escaped the south in 1838, traveling to New York, where he essentially became free, a journey that took little more than 24 hours! He and his wife settled in Massachusetts, becoming a licensed preacher and beginning a lifelong work as an abolitionist. In 1845, his first and best known autobiography, 'Narrative of the Life of Frederick Douglass, an American Slave', was published, selling over 11,000 copies in the first three years, going through nine reprints, and even being translated into Dutch and French. He spent two years traveling

through Ireland and Great Britain, speaking extensively before returning to the US where he continued proactively supporting abolition, along with women's rights.

So, what has any of this have to do with photography? Douglass is believed to be the most photographed American of the 1800s, even more so than his contemporary Abraham Lincoln. *Picturing Frederick Douglass: An Illustrated Biography of the Nineteenth Century's Most Photographed American* presents many of these photos and outlines how and why Douglass was photographed. He saw utility in photography as a tool to support the abolitionist movement and in particular, the 'truth value' of the camera to counter racist caricatures.

Douglass also published the first of several newspaper (the North Star) in 1847. Here then was an intellectual who used the power of mass media at a time when wood engravings were gaining extensive use to print graphics. Photography provided the linchpin in enabling graphically realistic imagery for mass reading.

* * *

Beyond The Cut

Other Ds that didn't make the cut include the Decisive Moment, darkroom, Louise Dahl-Wolfe, DATAR, Bruce Davidson, Jack Delano, depth of field, documentary, Robert Doisneau, Terence Donovan, DPI, dry plate, and dye transfer.

EXPOSURE

To misquote Bill Clinton:

It's the exposure, stupid.

As photographers we are created by light. It's what we measure, record, process, and display. Light is all we have, everything else is just a sprinkling of fairy dust on top. Without light we are nothing.

So, how we define light is crucial to what we do and the key term here is *exposure*. Exposure is the amount of light, measured in lux (lumens/m^2) seconds, that reaches the image plane. A simple analogy is to imagine a sink filling with water. The tap controls the rate of flow of water, whilst the length of time the tap is open for controls the overall volume. It's the same with a camera, where the aperture can change the amount of light entering the lens, with the shutter speed controlling the length of time light enters. It's worth noting that ISO isn't part of exposure.

Lux is a measure of luminous exposure which is weighted to the sensitivity of the human eye at a nominal 555 nanometers. For all incident radiation, or when it is calculated at a specific wavelength (such is infrared), it is called radiant exposure and measured in joules/m^2.

In photography, exposure is important in relation to the sensitivity of the film or sensor in the camera. We need to record enough light (but not too much light) to produce the artistic intentions we set out with. The conditions in which we photograph may force us to under or over expose and so it can be help-

ful to be aware of the exposure range of our sensor.

Given that aperture and shutter speed are the two primary controls on the quantity of light reaching the camera, it's useful to know the combinations of these that yield the same exposure. This is called the exposure value (EV) and was developed by Friedrich Deckel in the 1950s to simplify setting the camera and avoid having to remember shutter speed and f-number combinations. It is a base-2 (binary) logarithmic scale, based upon the f-number and shutter speed, where EV0 is f/1.0 for 1 second. Each EV change represents a stop (i.e. halving or doubling of the amount of light). When a camera meters a scene in aperture priority, the f-number will be set and so, to meet the EV required, it calculates the shutter speed needed to produce the desired exposure. If you dial in a bit of exposure compensation, then this will further adjust the shutter speed. In shutter priority mode a similar process occurs for aperture.

HAROLD EDGERTON

He wasn't an artist and, arguably, was only tangentially a photographer, yet Harold Egerton's technical and artistic contributions to the genre have been genuinely ground breaking paving the way for a new wave of expression. Graduating from the University of Nebraska-Lincoln in 1925, he gained his PhD in Electrical Engineering from the Massachusetts Institute of Technology by 1931 where he investigated the use of stroboscopes to study synchronous motors. There began a lifelong association with the technology to illuminate subjects that couldn't be seen by the naked eye, with a focus upon the public dissemination of those of everyday objects.

His work included the use of both short duration flash (current strobes hit T1 times between 1/400th and 1/20,000th of a second) and high speed multi-flash (up to 120 flashes per second) images. Famous works include hummingbirds, bursting balloons, a bullet piercing an apple, and milk droplets. Such were the uniqueness of his images that they made the crossover from science to art and subsequently adorned the walls of many art museums worldwide. Simply, they are beautiful, eye catching, and utterly illuminating to view.

What's astonishing about Edgerton is his sheer profligacy. He formed the company EC&G to commercially exploit strobe lighting, winning a range of contracts, including a primary contract for the Atomic Energy Commission which involved photographing and recording nuclear tests in the 1950s and 1960s. They developed the Rapatronic camera, a high speed camera capable of exposure times as short as 10 nanoseconds (ten-millionth of a second). Unsurprisingly, they didn't use a focal plane

shutter! Further innovation included the Krytron, a (very) fast switch for detonating a hydrogen bomb. In the 1970s and 1980s EC&G expanded into scientific, marine, environment, and geo-physical applications amongst others, peaking at 35,000 employees. Whilst the name has been discontinued, the firm, its inventions, and assets can be traced through to the URS Corporation. Edgerton's work was also pivotal in the development of side-scan sonar and he liaised closely with Jacque Cousteau, providing underwater photographic equipment.

Image courtesy 4924546 via Pixabay (tinyurl.com/yxrpkcgk)

However it is his work with strobes that Edgerton will be fondly remembered for by photographers where he received the nickname 'Papa Flash'. Whilst he clearly did develop cameras with fast shutter speeds, these were beyond the reach of the ordinary 'tog, however his research into the use of strobes in the 1930s led to their use in photography. Contemporary strobes typically store an electric charge in a capacitor before discharging it through a xenon filled gas tube. This results in a bright, short duration, 'pop' of light. The dimmer the flash, the faster the pop which is up to about 1/20,000th of a second. If

you get your exposure right, then the flash effectively becomes the shutter speed allowing you to record extremely fast objects. The Massachusetts Institute of Technology Edgerton Digital Collections Project houses a fantastic array of his images, including my favourite of a speeding bullet through an apple. However, please don't try this at home!

* * *

Beyond The Cut

Other Es that didn't make the cut include George Eastman, William Eggleston, Alfred Eisenstaedt, emulsion, Elliott Erwitt, and Walker Evans.

FUJI

Fujifilm Holdings — Fuji — is a longstanding camera manufacturer headquartered in Tokyo, Japan. In stark contrast to Bronica who operated post-war and began with the production of a medium format camera, Fuji was founded pre-war (1934) and were a film manufacturer. During the 1940s they incorporated the design and manufacture of optical instrumentation such as glasses and lenses, before expanding in to print, electronic imaging, and magnetic materials. In 1962 Fuji formed a joint venture with Xerox to market photocopying equipment in the Asia region.

Fuji rapidly became the single largest manufacturer of film in Japan, gaining significant market share worldwide. Many of their brands, such as Neopan and Velvia, have become synonymous with specific styles for photographers. Their expertise in colour and tone is used extensively in their digital products with a range of different film simulation modes.

Fuji produced their first camera in 1948, the Fujica Six, a beautifully crafted folding 6x6 viewfinder. I love the diversity of innovation they claim for the 1980s: the manufacture of floppy discs, creation of the disposable camera, and the first digital camera (unlike the 1981 Sony Mavica which was an electronic still video camera or Kodak's 1975 beast). Two of those we now think of as antiquated! The Fujix DS-1P (and subsequent DS-X) was released at Photokina in 1988 to great fanfare as the first camera to use a fully digital workflow saving images from a 2/3" CCD to a memory card. The main limitations to digital camera production in the 1980s were both the high cost of semicon-

ductors for memory cards and manufacture of imaging sensors. Fuji took the economic plunge and jointly developed a 2MB memory card (with Toshiba) to record their 0.4MP images. It all sounds a little trite now when we look at these specifications using our contemporary eyes. If you bought the entire system, which comprised camera, memory card, card reader, and a Digital Audio Tape drive, then it would have set you back $20,000. If you think that sounds a lot, then think again. When you factor in inflation, that is equivalent to somewhere around $40,000 today! Yes, Fuji were marketing a camera at a similar price point similar to Phase One or Hasselblad today.

The innovation didn't stop at the DS-1P, with the 1990s seeing a steady stream of development. This included the DS-100 (first 3x optical zoom and SRAM memory cards), DS-200f (first battery free memory card), DS-220 (first lithium ion camera battery), DS-505 (first 35mm field-of-view digital camera), DS-7 (first smart media cards), and Finepix PR21 (first in-built colour printer).

Fuji is an interesting example of a company known as a film manufacturer that successfully pivoted, or led the way, into the digital world, in stark contrast to their US counterpart, Kodak, who oversaw a gargantuan corporate blunder. Of course, the truth is a little more nuanced as the history above suggests. Fuji had manufactured cameras since 1948 and garnered extensive experience of the imaging market. That experience was extensive since it designed, manufactured, and sold into consumer, professional, and commercial markets.

The development of digital cameras should, at least in part, come as no surprise. They were also a large company (currently 78,000 employees) that had vertically and horizontally integrated across markets: they made cameras, lenses, and film, that developed and sold into business and medical imaging applications. The key question was not whether they would transition to digital, but rather how they handled the downsizing of their film business (and one that Kodak should have asked them-

selves more carefully).

That they took such an early lead was likely down to industrial design, electronics experience, and manufacturing expertise. Their camera business began gaining traction in the 1960s with a number of different designs; however, it was from the 1970s that development gathered pace with a 35mm SLR range, initially using a screw mount and subsequently bayonet based (using the original X mount). However they also manufactured medium format (fixed and interchangeable lens), compact, subminiature, disc, instant, and APS cameras amongst others (see the CameraWiki).

The production of point-and-shoot the DS-1P was perhaps understandable: simplify the optical design in order to simplify the electronic design. That it ushered in an era of SLR abandonment from which they haven't returned is a fascinating business decision. There were still Fujix branded SLRs, but these were produced in collaboration with Nikon such as the DS505 (or Nikon E4 depending who you bought it from). This was the first digital camera that gave the same field of view as a 35mm film camera, paired with a 1.3MP 2/3" sensor — and in the same vein as the DS-1P, it cost $15,000. The early 2000s saw a slew of Finepix S-series DSLRs using Nikon bodies. However, it was the oeuvre of compact cameras that followed, using the tried and tested mantra of 'pile it high, sell it cheap' (or not so cheap) that marked Fuji's digital offerings.

Image courtesy Bru-nO via Pixabay (tinyurl.com/y697bhw6)

That is, they were the offerings, until that market segment imploded with the creation of the smartphone. Fuji had to find a new direction of travel and, internally they must have pondered going DSLR or following Panasonic and Olympus into the new territory of mirrorless and micro-four thirds. They very specifically targeted a market segment: high value, portable, cameras that sat above compacts, but weren't as expensive or sophisticated as full DSLRs. To test the waters they released the retro-styled X100, using a hybrid optical viewfinder. Unlike Canon and Nikon, they are able to draw upon their own semiconductor business and genuinely offer something different to the competition: here is a camera manufacturer with electronics design experience that can marry the camera experience of the likes of Canon and Nikon, with the electronics experience of Sony. This was followed by the interchangeable lens X-Pro1 which was based around their own X-Trans APS-C sensor, that broke the waters for a new range of X-mount lenses. Fuji have also worked hard with photographers to improve their products — notable is the 'kaizen' approach to generous firmware updates, in contrast to Sony's rapid hardware changes.

Perhaps the biggest surprise for photographers, however, is the immense success of the instant photo Instax product line (both cameras and instant film). In 2018, Fuji had a gross turnover of ~ $23 billion, of which only 16% came from its imaging section, made up of 11% from photo imaging and 5% from electronic imaging. Simply, it's Instax business (and other print services) turnover is twice as much as camera/lens sales and are the source of much of the profit for this section. Instax is good business, sells more cameras than digital, and reflects a consumer market that wants instant photographic prints and the cameras to produce them.

Both Instax and the X-Series have undoubtedly been a success and have now been followed by their medium format GFX system which takes Fuji back to its roots. Whether the medium format/APS-C split is what the digital market wants, remains to be seen, with Sony, Nikon, Canon, and Panasonic all going full-frame mirrorless. Or have Fuji bet their future on a prosumer sub-market, backed up by the hordes of Instax consumers? What does the future hold for Fuji?

FAMILY OF MAN EXHIBITION

The Family of Man (FoM) was an ambitious photographic exhibition envisaged and curated by Edward Steichen, Director of the New York Museum of Modern Art's (MoMA) Department of Photography. Photography exhibitions weren't new, so what was it about FoM that made it so different? Let's start with the raw numbers.

It ran for 104 days from 24 January to 8 May 1955 and was comprised of 503 photo panels and 50 text panels from 273 photographers. It toured the world for eight years, visiting 37 countries on 6 continents and was viewed by more than 9 million people.

So, what was The Family of Man? It is described by MoMA as a

> *...forthright declaration of global solidarity in the decade following World War II*

and, as noted above, based around a series of photo panels, interspersed with text following the form of a photo-essay, a format I suspect John Berger would have approved of. Steichen had invited photographers to submit works that were;

> *made in all parts of the world, of the gamut of life from birth to death, with an emphasis on the everyday relationships of man to himself, to his family, to the community, and to the world we live in*

and, in so doing, demonstrate the "*essential oneness of mankind*". Or as Sarah Roberts notes, "*a visual manifesto of peace against the backdrop of the cold war.*" Quotations accompanied the photos from authors such as James Joyce, Thomas Paine, Lillian Smith, William Shakespeare, and Bertrand Russell. Carl Sandburg wrote an accompanying poetic commentary.

Whilst decidedly Western in scope, the sheer breadth of life that was taken in, presenting visual and written narratives, is mesmerizing in its audaciousness. This was an exhibition that wanted to reach beyond boundaries of anything that had gone before. Besides the scale of the numbers above, what I find remarkable is that the accompanying 192 page exhibition book, 'The Family of Man', is actually still in print!

The newly formed United States Information Agency toured the exhibition using five versions under the auspices of the MoMA International Programme. Notably, it didn't display in Spain, Vietnam, or China. Copy 1 toured Europe, copy 2 primarily toured the Middle East, copy 3 also went through Europe (and was donated for permanent display at the Common Market Headquarters in Luxembourg), copy 4 went around South America and Asia, and copy 5 finished in Moscow. The exhibition is permanently archived and displayed at Ciervaux Castle, Luxembourg, and is now part of UNESCO's Memory of the World Register. All of which means, even though FoM was curated and first exhibited over 60 years ago, not only can you buy the book, you can also go and see it for yourself!

Edward Steichen was no stranger to photography. Born in Luxembourg in 1879, his parents emmigrated to Chicago in 1880. He showed artistic talent early on and acquired his first camera in 1895. He was introduced to Alfred Steiglitz in 1900, who praised him for his work and bought several of his images. That started a lasting partnership in which Steichen was the most printed artist in Steiglitz's Camera Work (1903-1917). Together they opened the gallery Little Galleries of the Photo Secession which simply became known as 291. During this period

Steichen also photographed a series of gowns for *Art et Decoration* which are now considered the first fashion photos and so started a profitable career in fashion photography shooting for Condé Nast, Vanity Fair, and Vogue (for which he is thought to have been the highest paid photographer at the time). He also served in the US Army as a photographer during World War 1 and won an Oscar for Best Documentary in 1945 ('The Fighting Lady') before finally heading to MoMA. That is some career and placed him in a unique position to curate the FoM.

Of the 273 photographers whose work was used in the exhibition, 163 were Americans and 70 European. There were 40 women photographers in total. Steichen drew heavily on work that had been published in magazines, with 75 from Life, but also including Fortune, Argosy, Popular Photography, Harper's Bazaar, Time, and Picture Post. The vast majority of photographers supplied single images, with a handful supplying more. Wayne Miller, co-curator with Steiglitz, supplied the most and was known for his two Guggenheim Fellowships, as well as freelancing for Life.

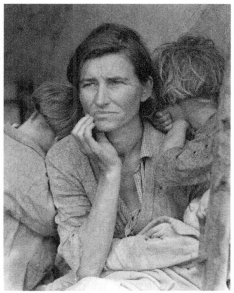

Image courtesy of Library of Congress, in the Public Domain (tinyurl.com/y2dp-g8uq)

The list of names is startling, including Ansel Adams, Diane Arbus, Richard Avedon, Margaret Bourke-White, Bill Brandt, Brassai, Manuel Alvarez Bravo, Lewis Carroll, Robert Capa, Henri Cartier-Bresson, Jack Delano, Elliott Erwitt, Robert Frank, Dorothea Lange, Lee Miller, Carl Mydans, W Eugene Smith, Edward Steichen, Edward Weston, and Gary Winogrand amongst many others. Along with the photographers came their photos perhaps the most famous being the influential Migrant Mother, however there are many other touching and searing moments. The poster image for the book is a Peruvian boy playing the flute — this forms the front cover and then, like the Pied Piper of Hamlyn, leads viewers on a hypnotic journey reappearing along the way. Images include an Inuit mother and child hugging, four generations of farm workers in the Ozarks, rice fields in Sumatra, a recent Mexican grave, sea bathing in Coney Island, rows upon rows of washing in the city, a US solider in Korea, Wayne Miller's new-born child, Albert Einstein at work, and a woman cleaning a doorstep in London's East End.

Whilst there were glowing tributes about the positive message portrayed in an era of post-war insecurity and the cold-war nuclear threat — particularly its intent to show the 'oneness' of mankind through a broad humanism — it had many critics. These included notable philosophers Roland Barthes, John Berger, and Susan Sontag; Sontag comments in On Photography:

> *they wished, in the 1950s, to be consoled and distracted by a sentimental humanism. ...Steichen's choice of photographs assumes a human condition or a human nature shared by everybody*

In short, they believed the exhibition refuted notions of difference and so conflict and injustice, oversimplifying a complex world to the point of becoming sentimental. In the tersest possible way, they were saying, *"Life's tough. Get over it."*

If nothing else the Family of Man presents a rich oeuvre of life with an undeniable positive message. We are all in it, in "'life', for the duration. We are born, we work and play, have families, are happy, sad, and everything in between, before eventually dying. That is what we know and it happens the world over. Judge for yourself and, if nothing else, you will see the rich tapestry of life from the world's best photographers.

* * *

Beyond The Cut

Other Fs that didn't make the cut include the Farm Securities Administration, Roger Fenton, ferrotype, film, filter, flash, focal length, Robert Frank, fresson process, Lee Friedlander, Francis Frith, Fstoppers, f-mount, field of view, and f-stop.

MIKE J. SMITH

G

NAN GOLDIN

Most closely associated with the LGBT community in the US, Nan Goldin's most notable, and breakthrough, work was 'The Ballad of Sexual Dependency'. Born to middle-class Jewish parents, the pivot point in her life was the suicide of her older sister when she was age 11. So began a tumultuous period that eventually led to her photographic journey through the gay and transgender communities in Boston, documenting the lifestyles of drag queens. This cemented her reputation for photographing the culture she lived in, showing the turmoil, tenderness, and ferocity of daily interpersonal relationships.

This led to her enrolment in the School of the Museum of Fine Arts (now part of Tufts) in Boston, before her graduation in 1978. At this point she moved to New York City, living and working in the work-hard/play-hard, high energy, gay community of Manhattan's Lower East Side. She trained her camera on both her friends and herself, and this material is unflinchingly presented in 'The Ballad of Sexual Dependency' (a name taken from Brecht's Threepenny Opera).

You can potentially categorize her images as 'snapshots', taken with the intent (at least with 'Ballad') to present a broadly coherent diary that details the relationships between couples, their lifestyles, and their broad interaction within communities. That this community, which she was a part of, was hedonistic and addicted to hard drugs led to an intimate portrayal of a vulnerable group that that suffered from physical and mental issues. This is graphically presented, for example, in the image 'Nan one month after being battered' which leaves no holds barred. However, it is a tender portrayal of a community that

lived, played, and, eventually, died together. This was the gay community of 1980s New York which was ravaged by AIDS — Goldin captured those highly personal relationships and refers to them both as a volume of loss and a ballad of love.

'Ballad' continues to define Goldin and her subsequent work is overshadowed by the lofty heights it reached, however it also reveals her journey through life and into parenthood. She has experimented beyond traditional prints, using photo books extensively but also multimedia such as slideshows, moving imagery, voice overs, and music. Works include collaboration with Nobuyoshi Araki (a seemingly destined pairing!) and a fiction/photographic book with Klaus Kertess about boy prostitutes in SE Asia. In many ways these displace the familiar content to new locations. Maybe it plays to the trope of marginalized peoples, but her work doesn't come across as exploitative. More recently Goldin revealed a recovery programme for prescribed opioid addiction, specifically OxyContin. As a result of this she has campaigned against its manufacturers, Purdue Pharma, as well as the philanthropic donations of its owners the Sackler family.

GOLDEN TRIANGLE

It sounds like a better alternative to the Bermuda Triangle, and also doesn't refer to the opiate trade, Indian tourism, Cheshire, or Texas. No, the Golden Triangle of composition is one of those age-old 'rules' that has guided the hand of painters and photographers for centuries in terms of composing a visually more pleasurable and appealing image, particularly where there are diagonal elements present. Of course, that is a subjective notion, but follow the process here and see if it works for you!

For the 'direction of travel' of features in your image, draw a diagonal line that connects the corners of your frame, then draw a line from one of the other corners so that it intersects this diagonal at 90 degrees. Do the same for the final corner. Your grid lines should look similar to the images below.

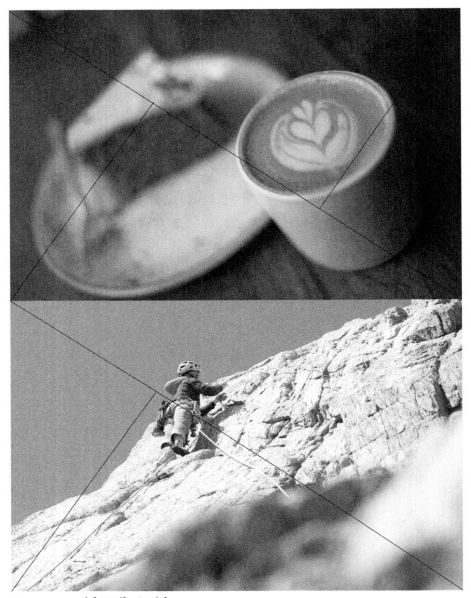

Images copyright Mike Smith

The intention is to create compositions that align features along a diagonal which, generally, means adding depth to your images. Where the second diagonal intersects is called the 'eye'

and you will often see photographs that draw the viewer in along the diagonal to this point. Whilst features may not perfectly overlie the eye, you will often see them positioned close to it in a manner that is not too dissimilar to the Rule of Thirds. What I like about the Golden Triangle is the implicit use of depth, something that was probably more important for painters to consider in terms of creating more 'energetic' pictures.

The Golden Triangle can also include a second diagonal drawn from the final corner to create a second 'eye'. This again can work compositionally by placing points of interest at these intersections. Painters also used the sub-triangles as areas that could be compositionally filled (or, for negative space, kept empty). The coffee image above uses the two intersections for points of interest.

Whether this is a useful method when you are out shooting remains to be seen and, as far as I'm aware, no camera includes guidelines for the Golden. That said, Photoshop can actually place guidelines on your computer screen for you; so, there is no excuse for not pulling up some of your favourite images and seeing if they bear any relation to this rule.

* * *

Beyond The Cut

Other Gs that didn't make the cut include Gallery291, Anne Geddes, gelatin (silverprint), Bruce Gilden, Baron Wilholm von Gloeden, Jim Goldberg, Group f/64, gum bichromate process, Gitzo, Graflex, and gigapixel photography.

MIKE J. SMITH

HYPER-LAPSE

As photographers we deal in exposure and in so doing, have the ability to manipulate aperture and shutter speed. Exposure is of course only part of the story, and any changes we make have artistic implications. With shutter speed, the control is over time and setting it relative to any motion in the scene allows us to achieve specific visual effects. Video is the next logical step in recording time, usually taking individual stills frames shot at 24 fps so allowing the capture of relatively smooth motion. However, what happens if you want to step outside of the 24 fps restriction by either expanding or compressing time?

When expanding time, we slow down events as they happen, allowing motion to be tracked that would otherwise be too fast to see. This is the territory of high speed capture. Following in the footsteps of Harold Edgerton, today we can use consumer cameras that are able to shoot at 1000 fps (such as the Sony RX100 IV) which means you can slow time down by 40 times.

The other option is to compress time and so speed things up which means shooting slower than 24fps. In this instance you enter the realm of time-lapse and are only constrained by your patience! Digital photography has led to a resurgence in interest in time-lapse because the barrier to entry is low, restricted only by your ability to shoot more photos. With all your stills frames in place, you simply combine them in to a video file and enjoy the results. Time sped up can be captivating, such as this example of the cruise ship AIDAprima being built (tinyurl.com/yyw6uuqr).

Hyper-lapse can be broadly defined as a time-lapse (hence the lengthy exposition!) where the camera moves. Leading propon-

ent Geoff Tompkinson sees that movement as over considerable distances rather than simple pans and tilts that some time-lapse incorporate, even where they use motorized rigs.

Hyper-lapse has typically involved — counterintuitively — shooting video in real time, and then removing unwanted frames in order to speed up motion. The problem this creates, particularly with unstabilised video, is a product that is visually jarring and unpleasant to view. The solution, unsurprisingly, has been computational photography! Algorithms smooth the motion between frames to create something that feels more like a fly-through. On iOS, Instagram produce Hyperlapse, whilst on Android there is Microsoft's Hyperlapse Mobile. The Microsoft Research webpage has an informative video (tinyurl.com/ycksm79v).

There is actually a second way to create hyper-lapse videos, as this example from Eric Stemen of Louisville shows (tinyurl.com/m6oy2ol). The technique is to use the time-lapse methodology, but now incorporating camera movement, typically through the use of a motorized rail system. If you imagine that this takes a long time then you'd be right! Stemen estimates a 5 second shot typically takes 15-45 minutes, but can run anywhere up to four hours! The full 4:23 clip took 357 hours to produce, however the results are stunning and, because it's still photos and not video, it allows you to capture imagery that is otherwise difficult to produce. For example, his night shots are typically of the order of seconds in length allowing him to capture light trails.

Of course, if a technique is as easy to produce as using a Hyperlapse app then everyone will use it, so to stand out from the crowd you need to be different. Which is exactly what makes Stemen's hyper-lapse videos so stunning.

HORST P. HORST

A German born American photographer, Horst P. Horst rose to prominence in the uber-chic 1930s fashion scene of Paris before moving to New York, serving in the US Army as a photographer, then resuming his career as a leading fashion photographer.

If you were to try to categorize the most prominent work of Horst, then it would be the fashion still life, adding surreal, even whimsical, elements to visually play upon shape. More than that he was highly artistic, and a master of exploiting the interplay of brightness and shade, darkness and light, in his compositions, making them striking, even arresting.

His most well know work is the 'Mainbocher Corset'. Is it the most eye-catching fashion shot ever made? Possibly. It's unashamedly sexually charged, erotic in the way it doesn't reveal, leaving the viewer to interpret it in their own way. It is also simply conceived using a minimum of props, a pose that continually asks you to question why, and the back of the model displaying all of the corsetry marvelry, her face obscured from view. For anyone that has tried to shoot these types of images, the simplicity is hard to achieve. Light sculpts the body, creating gradations from white to black. Being able to reveal shape so delicately takes a master who has acquired lots of practice.

Horst moved to Paris in 1930, initially to study architecture, but became friends with, and assisted, Vogue photographer George Huene. He had his first photo published in Vogue 1931 and his first solo show in 1932 which subsequently propelled him to prominence. In 1938 he moved to New York and continued to shoot for Vogue. In all, he had a working life of 60 years, eventually passing away in 1999. Unsurprisingly, he is

known for shooting women and fashion, something his selected works show. He is also known for nudes, both male and female, along with architecture, still life, macro, and environmental portraits, along with many a Hollywood star. Whilst we primarily associate classical black-and-white work with Horst, he was a deft hand with colour, used in a similar manner to his mono work. Colours are striking and used to accentuate shape. For more details on Horst's life and some more examples of his work, the V&A Museum have an introduction, (tinyurl.com/y36ss9a4) along with media related to works on display in their Photography Centre. (tinyurl.com/y36fcacu).

※ ※ ※

Beyond The Cut

Other Hs that didn't make the cut include Hasselblad, Ernst Haas, David Hamilton, Harper's Bazaar, Lady Clementine Hawarden, John Heartfield, heliography, John Herschel, Hill and Adamson, Lewis Hine, David Hockney, hologram, Dennis Hopper, humanist photography, Frank Hurley, halftone, Harris shutter, high key, and HDR.

IMAGE STABILIZATION

Invisible in use, image stabilization (IS) is one of those technologies that works tirelessly behind the scenes, operating at the lowest hardware level of the camera and often forgotten until you draw upon its capabilities. It's an unsung hero and if automatic exposure/automatic focusing were the poster children of the analogue 1900s, then IS is a technological marker of the digital 2000s.

So, what is image stabilization? Rather than a single technique, it is a series of methodologies that attempt to counteract small movements of the camera and so reduce image blurring that might occur as a result. The low-tech solution to camera motion is the tripod — simply attach your camera to something that doesn't move and you have a stabilized shot! Where tripods aren't practical then you need to control at least one of two elements in the image capture system of the camera to compensate for any external motion. Those elements are the optics and sensor, which leads to optical image stabilization (OIS) and In-Body Image Stabilization (IBIS).

OIS corrects for motion of the lens before light hits the sensor. Nikon call it Vibration Reduction and Canon call it Image Stabilizer. They both work by having a floating element in the lens that is controlled by an electromagnet. Accelerometers detect movement and these are translated into corrections for the floating element. OIS typically corrects for yaw (left-right rotation) and pitch (up-down rotation) changes, but not rotation around the lens axis.

OIS brings IS to the camera you mount it on, however the downside is that it needs to be implemented in each and every lens. The alternative is IBIS which also calculates movement compensations, but moves the sensor itself. This obviously works for any lens you mount on the camera body meaning there are no requirements to replace a complete lens system. Some implementations can also correct for rotation around the lens axis.

Photographers are used to using the '1/focal length' rule for minimum shutter speed so that, for example, a 50mm lens would require a speed of 1/60th. IS typically brings 3-5 stops of improvement meaning handheld shots down to around 1/2s would be possible. Panasonic was the first to market with a combined OIS/IBIS system which brings the best of both worlds and up to 6.5 stops of stabilization. Of course, whilst this can compensate for movement of the camera, it can't stop movement of your subject!

INTO THE JAWS
OF DEATH

One of several iconic photos from World War 2, 'Into the Jaws of Death' shows the U.S. Army 1st Infantry Division landing at Omaha Beach during the D-Day landings on the French Normandy coast, 6 June 1944. It's a remarkable photo on a primeval level and works, not because of any technical brilliance, but simply because the key elements came in to play. So, what are they?

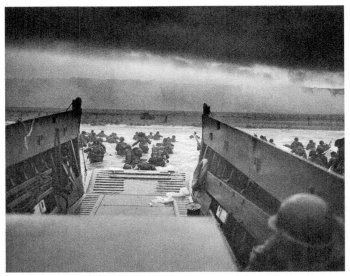

Image courtesy of Wikipedia, in the Public Domain (tinyurl.com/y67c24cd)

Firstly, as any war photographer will tell you, you had to be there. Secondly, what does the image show? There is an empty

LCVP (Landing Craft, Vehicle, Personnel) which could carry up to 36 troops for shallow water landings. Beyond the empty craft you can see the water full of disembarked troops, both in front and to the right, hinting at the presence of other landing craft. They are heavily laden, soaked to the skin, wading forward in to a war zone.

Thirdly, the square crop suggests 6x6cm 120 film (perhaps a Rollieflex TLR) but could equally have been a 4x5" medium format or even a Leica 35mm, regardless of this there is effective use of leading lines to guide the viewer. However there is no compositional trick at play – you know that these troops were exiting the relative safe haven of the LCVP in order to capture a beachhead.

History will tell you that Omaha beach saw fierce resistance from a well prepared and battle hardened German Army and of the ~40,000 troops that landed, it is thought in excess of 5,000 lost their lives. The title is not a trite marketing ploy, but a simple statement of fact. American soldiers walked knowingly in to a death zone in the name of liberty. German machine gun positions would have defended fiercely. Some died directly from enemy fire, some from ricochets, some stumbled and were dragged down under the weight of their kit, drowning. Others would have died days or weeks later from their injuries.

Fourthly, you have the dramatic skies capping the scene, almost making the reality the men experienced inescapable. It is dark and foreboding.

Put yourself in the shoes of Chief Photographer's Mate Robert F. Sargent. Where have you been told to stand? How are you going to shoot the landing itself? Will it be a grab shot? It was a dark, overcast day...you need to guess your exposure, set your aperture, and pre-focus before shooting. How many frames were on a roll of film? Your heart is racing from the adrenalin, not knowing if you are going to be shot. Rewind the film, store, reload, then carry on – capture the carnage.

In short, this image encapsulates the D-Day landings — it is

visceral and draws you completely into the scene, giving you some hint of what it might have been like. More than that, the landings define the end of the first half of the century with its Victorian underpinnings and the ushering in of a new order, a new optimism for the future. It can be seen as a tipping point in the war, the point at which defence turned to all out offence; the beginning of the end.

* * *

Beyond The Cut

Other I's that didn't make the cut include inkjet, infrared, Instagram, iris diaphragm, IMAX, Ilford, infiniti cove, intentional camera movement, and Yasuhiro Ishimoto.

JPEG

An acronym for the Joint Photographic Experts Group, JPEG is actually a sub-group of the ISO/IEC Joint Technical Committee 1, Subcommittee 29, Working Group 1, or more catchily, ISO/IEC JTC 1/SC 29/WG 1! The two main standards organizations (ISO and IEC) came together in the early 1980s in order to work on digital still image file formats and are now responsible for maintaining the JPEG, JPEG2000, and JPEG-XL standards.

Digital imagery began to gain ground in the 1970s and, because of this, there was a need to add photo quality graphics to text based computer terminals, however file formats of the day were uncompressed so file sizes were large. This was at a time when hardware was slow and storage expensive. The rudimentary bit map (BMP) stored each RGB pixel value individually. This was improved with a simple compression algorithm used in Run Length Encoding (RLE) but something more sophisticated was needed for low bandwidth devices, connected by even lower bandwidth telecoms. Enter the JPEG.

The key philosophical underpinning to JPEG is to make an image visually appealing to the human eye. It takes continuous tones from a digital input, reduces them to 8-bit, before smoothing them to the point that the image appears almost indistinguishable from the original to the human eye. I say indistinguishable, but 'quality' is a user controlled parameter where you can increase the compression (for smaller file sizes and faster write speeds), at the expense of image quality. As a result, this process is known as 'lossy compression' because the original image data is discarded, typically achieving compression ratios of 10:1.

The JPEG codec involves compressing 8x8 windows of pixels systematically using a discrete cosine transformation (DCT). The aggressiveness of the compression is determined by how accurately the DCT replicates the original pixel values. The operation of DCTs on 8x8 blocks is why we see 'blocky' artefacts in poor quality JPEG images. It is also the reason for posterization which results in pixellated transitions between blocks across smooth tonal changes. It gets worse when you re-save JPEGs as the DCT is reapplied to the already saved image, causing progressive degradation. The introduction of lossless rotation was one solution to help ease the problem.

Other than in situations where you need small file sizes, fast write speeds, or social-media ready images, the recommendation is generally to retain the raw file as this will give greater latitude in post-production. Or if you don't want to do post-production! The strength of the JPEG format is that the standards group required its methods to be implementable without license fees. It was a good solution and free to use which consequently meant it became widely supported.

JPEG2000 was the first update to JPEG and offered mild increases in compression, but significantly greater flexibility. Ultimately it was too complex for its time. JPEG XT, published in 2015, extends the original JPEG format up to 16-bit and includes floating-point coding, lossless compression, and alpha channels. JPEGXL is at the draft stage intending to produce high levels of compression. The question remains... will we still be using TIFFs and JPEGs in 10 years time?

WILLIAM HENRY JACKSON

Born in 1843 and living to the grand old age of 99, William Jackson epitomizes the life of the hard-working settler of the American West. His love of the arts, and painting, was inspired by his mother Harriet, herself a talented water-colourist. In 1862 (aged 19) he enlisted in the Union Army, serving for 9 months and fighting in the Battle of Gettysburg. His regiment mustered out in 1863 and then in 1866 he travelled west to the frontier, arriving at the end of the line near Omaha, Nebraska. He settled in Omaha in 1867, setting up a photography business with his brother. It was during this period that he made now-famous photographs of American Indians in the surrounding regions.

In 1869 Jackson was commissioned by the Union Pacific Railway to document the scenery along the different railroads — now that sounds like one heck of a commission to me! As a result of that, he was then invited by Ferdinand Hayden to join the 1870 expedition by (what was to become) the U.S. Geological Survey to the Yellowstone River and Rocky Mountains. As the official expedition photographer he was the first to capture images of now iconic locations which included the Grand Tetons, Old Faithful, Yellowstone more broadly, the Colorado Rockies, and Mount of the Holy Cross (he is recorded for the first ascent along with Hayden). The expeditions and their images were also instrumental in Congress establishing Yellowstone National Park in 1872, the first national park in the U.S. A serendipitous beginning indeed, all resulting from being a photographer

in the right place at the right time, producing good results, and getting noticed.

Image courtesy of the Library of Congress and in the Public Domain (tinyurl.com/ y3kkpkma)

In terms of technological process, Jackson began using the collodion wet plate process — this was a significant improvement on the Daguerrotype but was still an involved process requiring sensitization of glass plates in the field, before exposure and development. A contemporary of Jackson was John Thomson who as a travel photographer had equally demanding locations. Jackson preferred working with multiple cameras which included a stereographic camera (which was probably at the peak of its popularity), a full-plate (8x10") camera, and an even larger 18x22" plate camera. To support his role as expedition photographer he had 5-7 men who transported his equipment — all of which makes our 35mm DSLRs seem somewhat ordinary.

He accompanied Hayden on all his expeditions through to

the last in 1878 before moving to Denver, Colorado, establishing a new photographic studio. He received specific commissions in Colorado, as well as for several railroads, before the World's Transportation Commission requested he photograph transportation systems across the world for the new Field Columbian Museum in Chicago. He spent 2 years completing the project, producing a portfolio of over 900 photos that is now held at the Library of Congress.

In 1897 Jackson shifted entirely into publishing, selling his archive of 10,000 negatives to the Detroit Publishing Company (DPC) and becoming their president in 1898. The DPC printed images ranging from postcards to large panoramas across all areas of public interest, working from a catalogue of 40,000 negatives and peaking at the production of 7 million prints annually. The company went into receivership in 1924 and was liquidated in 1932 with Jackson's negatives being sold to Edsel Ford, son of Henry Ford. The collection west of the Mississippi is now held by the Colorado Historical Society, including his famous photo of the Mount of the Holy Cross.

<p align="center">✳ ✳ ✳</p>

Beyond The Cut

Other J's that didn't make the cut include Sarah Jones.

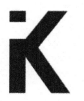

YEVGENY KHALDEI

A Russian naval officer and photographer, Yevgeny Khaldei is known for one of the most enduring photos of World War 2, 'Raising a Flag Over the Reichstag'. It is perhaps fitting that the photograph that depicted the international powerhouse of the Soviet Union, was taken by a photographer born two days after the Russian Revolution began.

The image was taken on 2nd May 1945 during the Battle of Berlin, the final major offensive of World War 2 in Europe. After several days of intense fighting, the building was seized, at which point Khaldei scaled the badly damaged shell in order to stage the photo that he had envisaged. He purportedly had a flag ready, sewn from three tablecloths, specifically for this purpose. Who is in the photo remains less clear, due to the Soviet propaganda machine — every aspect is politically charged, however Khaldei later said he asked three soldiers at hand, rather than anyone specifically. The image was taken — ironically — with a Leica III using a 35mm lens.

The image was published 12 May in Oganyak after Khaldei had returned to Moscow. It is also a good early example of misinformation in our era of 'fake news' — Khaldei removed the second of two watches adorning the wrist of the flag bearer (suggestive of looting) along with the addition of smoke in the backdrop to make it more dramatic.

Khaldei was born to Jewish parents in Donetsk, Ukraine, in 1917. Fascinated with photography from an early age, he joined the TASS news agency at the age of 19 before becoming a Red Army photographer in 1941. Khaldei supposedly travelled to Berlin with the specific purpose of staging a 'raising the flag'

photo at the Reichstag which, upon publication, made him famous across the USSR. After the war he photographed the Nazis at the Nuremberg trials before being made redundant in 1948 due to downsizing. He operated as a freelance photojournalist through to 1959 before joining Pravda, working for them until his retirement in 1970. His work was subsequently discovered by the West following retrospective publication in the 1980s.

Khaldei's work remained hidden from western eyes for much of his life and whilst, in contrast, the Family of Man can be seen as western iconography, we can learn much about the foundation of a global visual lexicon by examining the work of photographers from other nations. It provides us with a much broader dictionary from which to understand the world.

This image is potent because it marks the victory of the communist left over the fascist right, the successful birth of a new nation both politically and economically. Capturing the Reichstag symbolized victory over the Nazis by conquering the very heart of Germany. It's not often an image can reach such lofty heights.

KODAK

Iconic amongst camera brands, through the lens of history Kodak can be seen as a leader and innovator that ushered in many technical developments that transformed the industry, including the introduction of digital cameras. However, what it will be remembered for is a gargantuan corporate blunder that ripped apart a highly profitable and successful company turning it into a shell of its former self, eventually filling for Chapter 11 bankruptcy protection in 2012 that saw it sell off its patent catalogue and film/scanner operations. It now focuses on manufacturing enterprise level inkjet print and packaging solutions, but, with a turnover of $1.5B, it's no slouch! So where did it all begin?

Kodak, was founded in 1880 by George Eastman and Henry Strong, manufacturing dry plates. In 1888 they started the production of cameras for novices and so began a core corporate strategy: sell the hardware cheap, then make high profit margins on the consumables. This might sound familiar if you own an inkjet printer! The savvy business acumen was the purchase of roll film patents and then their incorporation into a camera that anyone could use, which almost single-handedly created the market for amateur photography. Mass market photography had genuinely arrived. Initial cameras were box type, with folding versions subsequently introduced before the release of the long running Brownie in 1900. In 1930 Kodak started the first of 74 years listed on the Dow Jones Index. George Eastman died at the age of 77 (1932), committing suicide after health problems and leaving the briefest of notes:

To my friends, my work is done, why wait?

In 1935 Kodak started manufacturing Kodachrome, followed in 1936 with hand grenades! Yes, they were the 62nd largest military contractor in the U.S. during World War 2. It was also a period that saw the release of the Retina 35mm camera. The Starmatic, an auto exposure Brownie, arrived in 1959, then the Instamatic in 1963, the latter pretty much the last word in point-and-shoot film simplicity (and 50 million sales!). Steve Sasson demonstrated the first digital camera in 1975, followed by the invention of the Bayer array in 1976.

The 1970s marked Kodak's heyday where it was the number one film and camera manufacturer in the U.S., commanding 90% and 85% of the market respectively. The Kodakdisc arrived in 1982 (which seemed like a good idea at the time, but now looks faintly ridiculous!), then the world's first megapixel sensor in 1986, and the Digital Camera System (DCS) in 1991. The DCS was the first digital SLR, mounting a digital back on to a Nikon F3.

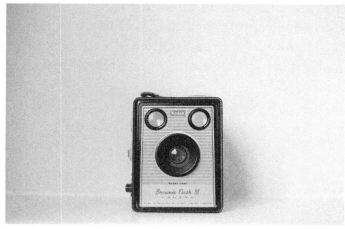

Images courtesy of Smart via Unsplash used under Creative Commons (tinyurl.com/y5ycnttl)

Even with these massive strides in its research laboratories and exploratory products, Kodak didn't pivot to digital until

the release of the EasyShare in 2003 which introduced the first camera dock on a printer for direct printing. The following year Kodak stopped manufacturing film cameras and was also delisted from the Dow Jones Index. However, the EasyShare system proved popular and the product line continued to develop with WiFi equipped and dual lens models. The smartphone effectively ended the low-cost digital camera market and after divesting itself of various sub-divisions Kodak eventually filed for bankruptcy that has seen it emerge as an enterprise print focused business. Interestingly, Kodak's liabilities to the UK Kodak Pension Plan (KPP) saw it spin off the Personalized Imaging and Document Imaging businesses and settle $2.8 Billion in KPP claims. KPP brought back Ektachrome in 2017 to much fanfare.

Kodak was a large company, peaking at 120,000 employees in 1973 and $10 billion sales in 1981. It is hard to do justice to a business like this in few short words. How the current Kodak's future develops remains to be seen, but it is worth remembering that it is really not a photographic company anymore. KPP handles the personal and document imaging, whilst the digital cameras have been spun off. Wherever you see the Kodak logo it may be hard to know who is actually behind it. A salutary lesson for any business, as well as an example of how assets and brands are split and sold.

<p style="text-align:center">❊ ❊ ❊</p>

Beyond The Cut

Other Ks that didn't make the cut include Andrew Kertesz, Nick Knight, kodachrome, Kodak, Joseph Koudelka, Kenko, KMZ, Kyocera, Konica, key light, kirlian photography, and Kiss at the City Hall Paris.

LENNA

Born in 1951, Lena Söderberg, pronounced Lenna, is a Swedish model whose claim to fame is being the November 1972 Playmate of the Month in Playboy magazine. Photographed by stalwart Playboy photographer Dwight Hooker, this went on to sell over seven million copies and become the best-selling single issue of Playboy. So, other than that it is a photograph, what on earth has this got to do with photography and why does it influence nearly every photographer today?

Lenna is what is called a standard test image. When developing image processing and compression algorithms in computer science it is critical to be able to visually and measurably compare their effectiveness. It allows you to determine both absolute effectiveness, as well as relative effectiveness in terms of how they compare to other algorithms. Whilst you can't say 'my compression method is better than yours', you can say 'using Lenna, my compression method is better than yours' The University of Southern California's Signal and Image Processing Institute (SIPI) hosts a library of common test images for a range of different purposes.

Given that Lenna is perhaps the single most used image in computer science history, why is it so appealing? To start with, it is obviously a human subject with skin tones which immediately makes it good for testing similar images. The light casts gentle tonal variations, which contrast with areas that have detail. As well as varying texture, there are also tonally flat regions, and shadows, along with a wide dynamic range.

Alexander Sawchuk was an Assistant Professor at SIPI and had had a colleague request a test image. Rather than use traditional

stock images, they looked for an alternative and happened across an issue of Playboy that was in the lab. Unsurprisingly this is also the reason for criticism in use of the image — it plays to male stereotypes in computer science and rather than use a science led approach in selecting a test image they picked something that appealed to them. The Journal of Modern Optics have suggested three alternative images that have a similar feature space (a pirate, cameraman, and peppers), whilst many journals (including Nature Research) now refuse to accept articles that use it. Irrespective of its origins, Lenna has had a significant impact upon photographers in terms of both the cameras and software we use.

LEICA

There is no brand in photography more emotive than Leica. The understated little red dot that adorns those gorgeously hewn blocks of metal that Apple pay homage to in their designs. Leica history goes back to the Optical Institute founded in 1849 in Wetzlar, Germany, to make optical instruments. However it wasn't until 1913 that employee Oskar Barnack produced the first prototype for a camera known as the Ur-Leica that used 35mm film and, in so doing, invented a format of photography that dominated the industry through until the digital age.

It wasn't until 1924 that Leica went in to mass production of the Leica 1 with a fixed 50mm f/3.5 lens in a collapsible mount, a top mounted viewfinder, and shutter speeds of 1/25 to 1/500s. One Henri Cartier-Bresson acquired a Leica 1 around 1930 and it was this that gave him the anonymity, flexibility, portability, and quality to pursue the new style of photography he was developing.

However, it was the introduction of two killer features in 1930 with the Leica II that turned photography, and particularly photo journalism upside down. These were the coupled range-finder and interchangeable lens mount. In one fell swoop, there was now a pocketable camera that could take a range of lenses and included a focusing guide to enable rapid shooting. The fact that the camera and lenses were of the highest quality made the product irresistible. The Leica III was produced from 1933 in parallel and was used by Yevgeny Khaldei to take 'Raising a Flag Over the Reichstag'

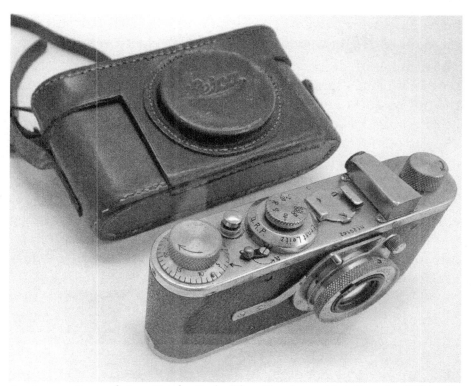

Image courtesy of Les Hotels Paris Rive Gauche - AlainB via Wikipedia (tinyurl.com/yxam8vgy)

In 1954 Leica cemented their reputation at the cutting edge of 35mm rangefinder design with the release of the Leica M3 which switched to a bayonet mount and coupled viewfinder-rangefinder that displayed bright framelines based upon the lens attached. The M2 ran alongside as a stripped-down M3, before the introduction of the M4 in 1967 which again improved upon the design and is perhaps considered to be the finest non-metered M camera. As the camera world moved on, Leica also introduced an SLR range in 1964 beginning with the Leicaflex; however, in comparison to rapid Japanese developments, these struggled to compete and Leica found itself in financial difficulties because of this and the badly received (metered) M5. M4 production restarted and moved to Leica's Canadian plant. The M4-2 that followed in 1977 had a simpler production process and saved Leica (followed by the M4-P in 1981). Paralleling this,

Leica SLRs were developed in conjunction with Minolta that introduced desperately needed in-camera electronic expertise. The film based M6 and M7 have followed, but were then superseded by Leica's rangefinder digital offerings that started with the M8 in 2006 and have largely followed an annual cycle of release. In 2015 Leica introduced the new L-mount for the Type 701, an APS-C mirrorless camera, and Type 601 a full frame model. Leica has now fully jumped into the full-frame mirrorless marketplace that has propelled Sony, Nikon, and Canon forward, with the announcement of the L-mount Alliance that includes Sigma and Panasonic, the first fruits of that labour being the Panasonic S1. If you are wondering whether to switch to full-frame mirrorless then there is a plethora of choice — just make sure you don't pick the wrong one!

Image courtesy Kenny Luo via Unsplash (tinyurl.com/y4aefu5a)

And the elephant in the room? The phenomenal cost of both the cameras and lenses. Yes, they are beautifully designed, beautifully crafted, and have an iconic brand status that is the equivalent of Apple or Porsche. The price is largely unrelated to the actual cost of producing the camera. You buy one because it is Leica. The fact that they are amazing cameras is incidental. Rent one for a day and try it out – you might just end up becoming a customer.

* * *

Beyond The Cut

Other Ls that didn't make the cut include Lensbaby, Lowepro, leaf shutter, light painting, long exposure, low key, Lunch Atop a Skyscraper (image), Last Jew in Vinnitsa (image), Leap Into Freedom (image), David LaChapelle, land art, landscape, Dorothea Lange, Jacques Lartigue, La Gras (image), latent image, Annie Leibovitz, lens, David Levinthal, Helen Levitt, Life, light, light meter, lomography, La Lumiere, and luminosity.

MIKE J. SMITH

INGE MORATH

Born in 1923 to Austrian parents, Inge Morath travelled around Europe with her family, before settling in Berlin in the late 1930s. Unlike many of her (slightly older) contemporaries, she remained in Nazi Germany during World War 2, entering Berlin University in 1941 where she studied languages learning French, English, and Romanian, to which she would later add Spanish, Russian, and Chinese. Toward the end of the war she fled back to Austria where she worked as a translator in war-torn Vienna and then as the Austrian correspondent for Heute magazine. It was here that she encountered the photographer Ernst Haas where they worked collaboratively for Heute. In 1949 they were jointly invited by Robert Capa to join the newly formed Magnum Photos in Paris where she became an editor. Here, she handled the contact sheets of work submitted by their members and where her visual literacy was first developed. Remarkably, she didn't pick up a camera until 1951 and then discovered her calling.

She married British journalist Lionel Birch, moved to London, apprenticed under Simon Guttman, then editor of Picture Post, before divorcing Birch in 1953 and moving back to Paris. She presented her first work to Capa who hired her at Magnum taking on the stories the other photographers didn't want. In 1955 she became a full member of Magnum (one of the first women) subsequently traveling widely and covering assignments for the likes of Vogue, Holiday, and Paris Match. She also covered motion picture movie sets and worked for the director John Huston. Huston later said of her:

[she] is the high priestess of photography. She has the rare ability to penetrate beyond surfaces and reveal what makes her subject tick

In 1960 she worked again for Huston on the set of 'The Misfits' photographing Marilyn Monroe and Clark Gable and it was here that she met the playwright Arthur Miller (at the end of his marriage to Monroe). They married in 1962 and remained so until her death in 2002. She worked closer to home whilst raising a family, although still travelled including projects with Miller himself. She was an active photographer right up until her death from cancer. The Inge Morath Foundation now manages an award in her name supporting documentary projects for women photographers.

View her work because it shows a beautiful simplicity, a humanism, and a connection with its subject. In short, there is a visual poetry that takes practice and something a little bit extra. It will help you grow as a photographer.

MINOLTA

Founded in Osaka, Japan, in 1928 by Kazuo Tashima, Minolta marketed its first camera, the Nifcarette, in 1929. This was a folding camera, co-designed with two German engineers. The body was made in Japan, with the lenses and shutters imported from Germany, shooting 4x6.5cm exposures on 127 film. This was followed by a twin lens reflex (TLR) in 1937 (the Minolta Flex) and a 35mm rangefinder in 1947 that used the Leica 39mm screw mount. The latter was a successful camera with over 40,000 units sold during its 12 year manufacturing run.

In 1958 Minolta released their first 35mm SLR, the SR-2. The SR-mount was the first bayonet designed mount (beating Nikon's F-mount to market by one year) and was used for all of Minolta's manual focus lenses. Research and development continued apace, with the SR-3 taking an exposure meter and through the lens (TTL) metering introduced with the 1966 SR-T. Coupled with the remarkable cameras was a range of high quality Rokkor lenses which Minolta designed and manufactured.

The SR-2 was world-leading in its day and began a highly successful period for Minolta that made it, arguably, the most innovative camera manufacturer of its time. Some of the firsts (or early adoptions) included a commercially successful autofocus SLR, multimode metering, and full program mode.

Image courtesy Rama via Wikipedia (tinyurl.com/y2won8eh)

This success led to a formal working partnership with Leica in 1972 who desperately needed expertise in in-camera electronics. The Leica CL, an affordable M, was the first fruits of this labour which was built by Minolta to Leica specifications. The Leica R3 followed, which was a rebadged Minolta XE-1 with Leica lens mount, viewfinder, and metering system. It was a commercial success and was followed by the Leica R4 which was an XD-11.

The 1980s saw Minolta transition to auto-focus cameras with the Maxxum range (Dynax in Europe and Alpha in Japan) and low-cost entry level 35mm models. The Maxxum 7000 is a good exemplar of the new range which switched from metal bodies, and analogue controls, to plastic shells, electronic buttons, and LCD displays. With AF came a new lens mount —

the A-mount — that used TTL phase-detection focusing and metering, auto-exposure, and predictive focusing. The 1990s saw continued development of the Maxxum line introducing a range of firsts such as eye-activated start-up, interactive viewfinder LCD display, and wireless TTL flash control.

Their first foray into digital cameras was with the DiMage point-and-shoot and bridge camera range. In 2003 they merged with Konica in order to bolster their market position and try to push in to the professional sector occupied by Canon and Nikon. Expectation was that Konica Minolta (KM) would fully enter the digital SLR market. This didn't happen until 2005 with the Maxxum 5D and later that year KM entered a strategic partnership with Sony before entirely exiting the camera market in 2006 with all remaining assets being transferred to Sony. That year the Alpha100 was released with a succession of Minolta based cameras through to 2010 when Sony began to pivot to mirrorless. So was born the Sony A-mount and now Minolta lives on in this forlorn, abandoned, lens system that is used in Sony's SLT cameras, but since the development of the E-mount has received little attention.

Image courtesy of Wikipedia (tinyurl.com/yxtpql2h)

For such a technologically focussed company that developed exciting camera products it was a low-profile exit. KM, however, remains an imaging company in the copier, laser printer, and digital print markets that now employs over 40,000 people worldwide and has a turnover of $10B.

<p style="text-align:center">* * *</p>

Beyond The Cut

Other Ms that didn't make the cut include Mamiya, Minox, Metz, Manfrotto, motion blur, multiple exposure, Migrant Mother (image), Marlboro Marine (image), Linda McCartney, Don McCullin, macro photography, Magnum, Man Ray, Sally Mann, Robert Mapplethorpe, metadata, Joel Meyerowitz, Lee Miller, mise-en-scene, Mission Heliographique, Tina Modotti, Laszlo Moholy-Nagy, MoMA, Eadweard Maybridge, and Carl Mydans.

N

(IMAGE) NOISE

A digital sensor reduces to a device that counts the number of photons hitting each individual photosite. They do this by converting the light to electrons and storing the electrical charge (like a solar cell), before transporting it across the chip to an analogue-to-digital convertor (ADC) that measures the charge and converts it to a binary number. Noise is any unwanted deviation in the actual number of photons recorded in each pixel when compared to the original photosite. This results in brightness variations in pixel values that can be seen as tonal or color variations in your image, as in this image of a circus performer shot on a dark stage at ISO 2200.

So where does noise come from? There are actually five main sources that can impact any image you acquire. Of these, two are important to understand as they can significantly degrade your images.

The first, Read Noise, is introduced by the ADC. Any analogue device is inherently susceptible to variations in performance, unlike the exact reproduction of digital data. Crucially, Read Noise is at a fixed level which means that it makes up a far greater proportion of darker pixels. There is nothing you can do about Read Noise but you can get a good idea of what it looks like by taking a shot with the lens cap on at the highest shutter speed and then viewing this. It is noticeable that sensor manufacturers have significantly improved the quality of their ADCs in recent years and images are much 'cleaner'.

Image copyright Mike Smith

The second type is Thermal Noise which occurs when electrons are released by a photosite — this grows with exposure time leading to the problem of 'hot pixels' loathed by astrophotographers. You can remove it by subtracting a dark image taken with the same exposure time.

The third main type is Shot Noise and has nothing to do with the camera at all. Nature is inherently random and that includes

the sun! Whilst it might look like a constantly bright source of light, it also suffers from random fluctuations. As an image is captured over a period of time, no matter how short, there will be natural variations in the incoming light. Unlike Read Noise, this follows a power law which means that at low light levels it makes up a significantly greater proportion of the pixel value than at high light levels. For the technical out there, photon arrival at the sensor is modelled using a Poisson distribution where the standard deviation is calculated as the square root of the mean.

It is this factor that has led to the advice for photographers to Expose to the Right (ETTR). By overexposing your image, without saturating any (or many) pixels, you significantly improve the signal-to-noise (SNR) ratio and can then reduce exposure in post-production.

Image copyright Mike Smith

Pixel Response Non-Uniformity leads to the fourth type of noise resulting from different efficiencies of individual pixels. This rises linearly with exposure but remains a relatively small component. Better sensor manufacturing processes have improved sensor noise.

Finally, there is Quantization Noise where the photon count is converted to the bit-depth of the recording format. Whilst a minor component, it is the reason we see the likes of Phase pushing 16-bit ADCs to give better tonal rendition.

It's beyond the scope of this short introduction, but there are a number of software packages, such as Lightroom, that allow you to reduce the effect of noise. Nevertheless, the best starting point is to understand where it comes from and shoot accordingly!

HELMUT NEWTON

Helmut Newton, or Helmut Neustadter, grew up in Berlin and was propelled to a hugely prolific, and influential, career as a fashion photographer for the likes of Vogue magazine. Born in 1920 to Jewish parents, his family was persecuted by the Nazis and he fled to Singapore in 1938 where he became a photographer. He was subsequently interned and sent to Australia, joining the Australian Army and then becoming a British citizen.

After the war he opened a portrait studio in Melbourne where he gained a reputation as a fashion photographer that secured a 12 month contract with British Vogue prompting his move to London in 1957, before eventually settling in Paris in 1961 where he shot for Harper's Bazaar and Vogue amongst others.

Given his influence and standing, what was his style like? Simply put, he was known for the erotically charged black-and-white images he shot for Vogue. These nude or semi-nude scenes often incorporated sado-masochistic or fetishistic elements, although not exclusively so. Perhaps this was typical of the male-dominated, sexually liberated, 1960s. Or maybe it was artistic porn hitting the mainstream. With the likes of Robert Mapplethorpe pushing cultural boundaries, it was clearly a time to experiment.

Perhaps more interesting from the perspective of current photographers, is understanding how he developed the vision which we see in the end product. For film photographers this is often shown in their contact sheets (such as the famous Magnum Contact Sheets), however by the pre-digital 1970s many photographers shot polaroids in order to nail the final image.

The book 'Helmut Newton: Polaroids' is a collection of the extensive catalogue of Newton's Polaroids and they give a great behind-the-scenes view of his shoots.

A heart attack in 1970 reduced his output, but he remained active through the assistance of his wife (also a photographer who worked under the pseudonym of Alice Springs. Yes, seriously!) which led to the high-profile projects Big Nudes, Naked and Dress, and Domestic Nudes. He died at the age of 84 from a car accident in Los Angeles, leaving a large portfolio of work now managed by the Helmut Newton Foundation.

* * *

Beyond The Cut

Other Ns that didn't make the cut include Nadar, negative, Nikon, Nicephore Niepce, Nautilus (image), and the nude.

MIKE J. SMITH

PAUL OUTERBRIDGE

Famed fashion photographer Paul Outerbridge was born in New York in 1896 and, after a brief stint in the US Army, was enrolled in the Clarence H. White School of Photography by 1921. In 1922 he had his first photos published in Vanity Fair: a shirt collar on a chequerboard (the 'Ide Collar') is a fine example of his beautifully lit, styled, and printed imagery. It is a masterclass in contemporary photography that is, remarkably, a century old. It is also a good example of his meticulous still life work which took everyday objects, lit them delicately in a carefully curated setting to produce a work of art, a thing of beauty. I like Outerbridge — his work epitomizes the svelte and stylish simplicity of the 1930s Bauhaus movement.

In 1925 he had a solo show at the Royal Photographic Society in London, before moving to Paris where he met contemporaries Man Ray, Marcel Duchamp, Pablo Picasso, and Berenice Abbott. With Edward Steichen, he briefly shot for French Vogue before bouncing backwards and forwards between Paris and New York, eventually settling in Monsey, New York. By this point the Metropolitan Museum of Modern Art acquired his work, only the second photographer in their collection.

So how is it that one of the best paid and well-known photographers of his era, who produced remarkably fresh and original work, died in relative obscurity from lung cancer in 1958? The short answer is that business, and particularly fashion photography, is a fickle beast and that the speed of ascent in the industry can be equally matched by the speed of a fall from grace.

One reason was technical: the 'Ide Collar' shows how adept he was with black and white chiaroscuro techniques, however he

then went on to master colour photography during its formative years using the Trichrome Carbro Process, subsequently writing a book on the topic ('Photographing in Color'). Unfortunately for him, Kodak released Kodachrome, the first modern three-color film, and the industry pivoted whilst he didn't.

This neatly introduces his colour imagery, which is as fresh and contemporary as his black and white work. If anything, it is even more so. For pioneering colour photography we often think of William Eggleston, but Outerbridge was well before his time. I've already touched upon the colour work of Helmut Newton, yet Outerbridge took the difficult Carbro process, combined it with his black and white envisioning, and added a twist of colour to remarkable effect. Yet colour remained shunned and perhaps his enthusiasm was misplaced in an industry that wasn't ready to move on. If you are interested in books then Taschen's Paul Outerbridge and Getty's Paul Outerbridge: Command Performance offer a great review.

The second reason is perhaps a little more insidious and seems a recurring theme for so many photographers, particularly those in the fashion industry. Outerbridge was fond of nudes, including styling fetishistic themes that had strong pornographic overtones, something that led to the suppression of his work. The fact that these were also in colour made the scene all the more vivid. It was the economic downturn for Carbro color, World War 2, and his nude work, coupled with a lavish lifestyle that led him to move to Hollywood in pursuit of a career in film. This didn't play out as expected and the remainder of his life was spent with trying to succeed in studio work, photojournalism, and writing. Whilst the nude is divisive as an art form, it seems that history has treated Outerbridge unfairly when the same mantle was carried by Helmut Newton to such universal acclaim and great commercial success. It was ultimately a low-key end to a remarkable life of creativity and invention. View Outerbridge's work – it will surprise and engage.

ORTON EFFECT

The Orton Effect is a post-production overlay technique first introduced by photographer Michael Orton in the 1980s. As an aside, photo manipulation has a long history that dates back to the birth of photography and likely by the 1830s. By 1860 it was well established with the portrait of Abraham Lincoln used on the original five dollar bill being a notable example. Of course, analogue techniques for manipulation had been well established from the in-camera double exposure, to developing the negatives (such as dodging and burning), and piecing together negatives or photos. Reijlander pioneered the technique, splicing together fragments of up to 30 negatives as early as 1857.

By way of preamble, it is clear that overlaying images is not new in photography. So what did Michael Orton bring to the table? In short, the technique adds a glow to an image with similar qualities to a halo where you get both softening, with detail, and highlighting. It can be almost dreamlike. Given that I'd never heard of the Orton Effect, I was surprised to find that it is used quite widely, particularly by landscape photographers.

Orton wanted to create an effect somewhat like a watercolour and, given this was pre-digital, required the careful sandwiching of transparencies where one slide was in focus and overexposed and the second was out of focus and overexposed. The first contained the detail and the second the colour. Not only did it require some careful work with transparencies, it was also time consuming. As a result, it was sought after. Don't take my word for — go and look at Michael Orton's explanation, along with some of his best work (tinyurl.com/cquoqb2).

Images copyright Mike Smith

Today, layer based post-production software makes it simple to produce to the point that it often has its own button! However, the process is straightforward in that you duplicate your candidate image and then apply some Gaussian Blur. The larger the radius the more dreamlike the image — adjust to your taste! Apply an extreme amount of contrast then reduce the opacity to zero, before slowly increasing it to a tasteful amount of glow. Some of the detail may have been lost by this point so you might want to add some sharpening to the original image.

<p style="text-align:center">* * *</p>

Beyond The Cut

Other Os that didn't make the cut include oil pigments, Gabriel Orozco, Timothy O'Sullivan, overexposure, Olympus, orotone, opalotype, and one-light.

MIKE J. SMITH

P

PANORAMIC PHOTOGRAPHY

Standing on the promontory, you gaze in awe at the vista before you, a huge expanse of space that seemingly sucks you in to a void, drawing you deeper and deeper. The vastness seems all the more claustrophobic, cloying at you. The panoramic scene has a special place in the human psyche such that when we are presented with it, our visual senses are overwhelmed. It manages to completely saturate our field of view, and as vision is our strongest sense, the result can be mesmerizing. Perhaps this is why we feel an absurd need almost to fall in to a scene — it can be hypnotic.

Image copyright Mike Smith

Unsurprisingly the panoramic takes a special place in photographic history. But first, what is a panorama? This seemingly innocuous question is more troublesome than it might at first appear, simply because we have to provide a hard bound to how we envisage it. Wikipedia describes it as wide-format photography or one that presents a horizontally elongated field of view or, more simply, a wide aspect ratio. The human field-of-view is about 160 by 75 degrees, so panoramic is at least as wide as that, which approximates 2:1.

The 35mm format is 3:2, so a panorama is considered wider

than this. But why 3:2? George Eastman (and Kodak) first manu-factured 35mm film, adopting the roll film format. However it was William Dickson's creation of the pre-cursor to the movie camera, the kinetoscope, working for Thomas Edison that popularized 35mm film with 18x24mm frames. The film ran vertically with four perforations on each side giving a 24mm width. Why 18mm high? Possibly because it gave 16 frames per foot of film (possibly 16 frames per second?). It was Leica that really defined the format by innovatively turning the cam-era sideways to give a wide image frame. This was doubled to two movie frames high, so moving to 36x24mm with eight perforations per frame and giving an aspect ratio of 3:2 What makes a good panoramic photo? Perhaps the best place to start is Epson's Pano Awards which shows that the format is alive and kicking with some amazing vistas to behold. Competitions are about playing to contemporary tropes whilst still offering some new insight and refreshing perspective. In short, being able to tell a story that hasn't been told before.

In the film world, shooting panoramic was difficult without a bespoke camera or darkroom manipulation, although the 1980s did see panoramic mode added to many cameras that shuttered the top and bottom of the frame. Professional photo-graphers also used swing cameras with long exposure times that allowed much wider captures. There have also been some stunning examples of panoramic photography, my favourite from the Library of Congress was captured by George Lawrence in 1906 in the immediate aftermath of the San Francisco earth-quake and subsequent fire. More remarkably, this was taken from a kite flying at 600m using a 22kg camera creating a single 17x48" contact print!

However, it was digital manipulation, and subsequently digital cameras, that revolutionized panoramas, revitalizing the for-mat. Being able to stitch multiple images together allows the ultimate flexibility in creating new compositions.

Image courtesy of the Library of Congress, in the Public Domain (tinyurl.com/y29k52ku)

Distortion free panoramas with perfectly overlapping frames require rotation around the nodal point of the lens, something that early photographers understood. However the true power of computational photography has come to bear over the last 10 years with PTGui a good example of stitching software that also makes colour and tonal corrections enabling the production of seamless panoramas. Lagging behind in features is the open source Hugin, which is also remarkably capable. This functionality is now widely supported with Lightroom, Photoshop, and Affinity Photo all performing well. Though it's been the integration of stitching into cameras and smartphones that has caused an explosion in their creation. As with much smartphone photography, it's the capability to capture images that once took a professional level SLR and computer from a device that fits in your pocket that has been transformative.

It's this latter point that has seen great strides including vertical panoramas, Gigapans, and 360/VR immersive environments. Which takes us back to the start of the article — panoramas are intended to be hypnotic because they overwhelm the visual senses. All of these technologies are natural cousins to the panorama and cement its place into the photographic lexicon.

PILLARS OF CREATION

No, not the Terry Goodkind novel, but the iconic photo of the Serpens constellation in the Eagle Nebula taken from the Hubble Space Telescope. Crucial to the success of Hubble was getting it above the Earth's atmosphere which gave it an unadulterated view of the galaxy. Shot in 1995 (although the image below was recaptured in 2015 with the newer Wide Field Camera 30), it shows elephant trunks of interstellar gas (molecular hydrogen) and dust which are in the early stages of forming a new star. The constellation is 5000-7000 light years away, with the leftmost pillar about four light years long (that's 23 trillion miles!). The Eagle Nebula was actually discovered as far back as 1745 and is one of the more spectacular formations, however Hubble imaged it in much more detail than previously achieved.

Scientists Jeff Hester and Paul Scowen from Arizona State University created the image and creation is the right word. It is actually a composite of 32 images taken from four different cameras. Whilst a 'normal' camera will record blue (about 400-500 nanometers), green (about 500-600 nanometers), and red (about 600-700 nanometers) light, this image works at 502 nanometers (oxygen), 657 nanometers (hydrogen), and 673 nanometers (sulfur) which were then re-mapped to blue, green, and red. Regardless of its creation, it is a breath-taking image that is beautifully imaged and deserves its iconic status in the pantheon of photography.

Image courtesy of NASA, in the Public Domain (tinyurl.com/y6por6hf)

* * *

Beyond The Cut

Other Ps that didn't make the cut include the palladium process, Luis Gonzalez Palma, Max Pam, paparazzo, panoramic, Trent Parke, Norman Parkinson, Martin Parr, Irving Penn, Gilles Peress, Jozsef Petzval, photo booth, Photo League, photogram, photogravure, photolithography, photosculpture,

Photo-Secession, photosensitivity, PhotoShop, Paint Shop Pro, phototype, Pictorialism, pinhole camera, pixel, platinum print, Polaroid, Herbert Ponting, portraiture, positive, post-production, print, projector, Panasonic, Pentax, PhaseOne, Profoto, Praktica, Phottix, panning, posterization, push processing, Photograph 51 (image), Phan Thi Kim Phuc (image), Pale Blue Dot (image), and punctum.

WAYNE QUILLIAM

Photographer Wayne Quilliam is a bit of polymath when it comes to photography, undertaking events, drone imaging, documentary, landscapes, videography, and contemporary art to name but a few. If I had two pick out two key areas then it would be his contemporary art and work with indigenous tribes across the globe that stand out.

Born in Tasmania, he began shooting whilst in high school, but it wasn't until he joined the Royal Australian Navy that he discovered his passion. He bought a Yashica FXD Quartz whilst in Hong Kong on deployment in the 1980s and was transfixed by using the camera as providing a 'version of record', documenting the lives of the sailors on a warship, along with the places they visited and adventures they had.

Upon leaving the Navy, Wayne wanted to explore his aboriginal heritage and undertook this through photography. Early influences included photographer Lisa Bellear and film maker Richard Frankland, yet it is a two-way street and Wayne recognizes that photographic heritage is only half of the story and shouldn't overshadow the future. He assists Amsterdam based Sinchi who promote indigenous photographers, working as a judge in their principle photo competition.

Wayne began his photographic career as a stringer working principally for the Aboriginal newspaper Koori Mail in the 1980s, but paying the bills meant also working as a chimney sweep, bouncer, and tiler. With the support of his wife Jodie, he made the jump to full time pro after getting his break at the Yeperenye Festival in 2001 (a major gathering of indigenous peoples in Australia).

Wayne has shot mostly with Nikon, currently using the D850 matched with a 70-200 f/2.8. Given that he does a fair amount of documentary work, he needs something robust and reliable, however he also has a Z7 with 24-70 f/2.8 for filming. As he travels to remote areas, weight is a key element. And most important of all, his favourite lens is the Nikkor 85mm f/2.8 Micro.

Given the variety of work he undertakes, Wayne's 'style' is somewhat diverse.

> *Style is a word that is rarely associated with me and this has been both a curse and a privilege.*

That seems a familiar refrain for many working photographers where you try to balance what you need to shoot with what you love to shoot. Because of his work with indigenous tribes he is perhaps best known as a documenter, however he prefers to describe it as

> *... [being a] storyteller [who] captures the essence of people in a respectful and humorous way.*

His work has opened doors to new opportunities, including helping the process of reconciliation between indigenous and non-indigenous people. He has travelled extensively, principally for NGOs, helping to document for those unable to do so for themselves and, in so doing, provide a non-confrontational way for them to express their 'essence'. Working with other peoples requires care and sensitivity. You cannot begin to understand the societal intricacies developed over millennia and so his expertise is in gathering knowledge and information to aid them in the process of communication. He shows no sign of slowing a recent exhibition saw his work printed on to Japanese silk before being embedded with ochre and plant dye and then shaped in to Aboriginal artefacts.

One of the most remarkable episodes in his career occurred with a call for a job working with a remote community in Bolivia. He went via Miami, where his flight was cancelled. He made the mistake of booking an 'affordable' motel and the night was interrupted by a shootout on the floor below, followed by a leak from the ceiling above. Arriving in La Paz the next day, the connecting flight was cancelled so another affordable hotel beckoned before arriving in Cochabamba to find all his gear was still in Miami! Using his emergency camera, the next two weeks involved revolutionary protests, landslides, broken axles, and stabbings. The actual job itself, thankfully, was immensely rewarding. He returned to Miami two weeks later to find his luggage was about to make the same flight back to Cochabamba!

THE QUEEN

We've already covered the most photographed place on Earth which turns out to be Central Park. Or possibly the Eiffel Tower, Disneyland, or the Solomon R. Guggenheim Museum, so take your pick! It's therefore natural to turn our attention to the most photographed person ever. This one is much harder to define and so measure, however our attention naturally focuses on the celebrity, be that in entertainment, sport, politics, or business.

Quora gives a nice sense of the scope with this question. There are historic celebrity figures such as Elvis Presley, Queen Elizabeth II, Princess Diana, John F. Kennedy, Justin Bieber, Elizabeth Taylor, Rihanna, Jesse Jackson, Paul McCartney, Michael Jackson, and Barack Obama. White House photographer Pete Souza reckoned he shot 500-1000 photos a day personally, with his team creating up to 20,000 images per week which makes the President of the United States a pretty hot topic. If you think about sport with a stadium full of fans all taking pictures with their smartphones, does that tally up to even more?

Image courtesy the Library of Congress in the Public Domain (tinyurl.com/ y34mb745)

From a technical perspective, you could throw in motion pictures and count all the still frames in which case Indian actor Brahmanandam Kanneganti would have a shout with his over 1000 feature films. The Quora answer reckons that adds up 14.4M photos if he was on screen for 60 minutes of each film with a 10:1 shooting ratio, however maybe that is stretching the definition of 'most photographed'. And then there is the 'cult-of-self' with our current crop of celebrities, such as Kim Kardashian who supposedly took 6,000 selfies on a four day trip to Mexico, which all adds up to a wealth of self-promotion.

Which brings us neatly back to the Queen who has the two criteria for 'photographiness' — celebrity and longevity. Most people lack these two key components. They either live a long life of obscurity or a short life of blinding celebrity (or somewhere in between). The Queen, by dint of being a Royal when there was still the vestige of an empire and ascending to the throne at the age of 21, has never been out of the limelight, as this article suggests. Will there be anyone to surpass her enduring celebrity?

Image courtesy of Joel Rouse (Ministry of Defence) and nagualdesign (via Wikipedia) under Open Government Licence (tinyurl.com/y5sx7826)

* * *

Beyond The Cut

The other Q that didn't make the cut this week was Archiles Quinet!

MIKE J. SMITH

R

REFLEX CAMERA

The Reflex Camera is at first an odd name as, unless you are an English graduate, it sounds like a knee-jerk response to being hit! Reflex also means to 'reproduce the essential features of something else' which makes sense in the context of photography as it's a camera which shows the scene to be photographed as the lens sees it. This is in stark contrast to cheap 35mm point-and-shoot cameras which often had no viewfinder, or indeed the complex rangefinder system (such as used by Leica) which put framelines inside the viewfinder for different focal length lenses, correcting for parallax differences.

Perhaps a simpler definition would be to call it a WYSIWYG Camera — What You See Is What You Get! By my reckoning there are three solutions to this problem. The first of these is a bit of a fudge as it has two lenses side-by-side, a setup known as the twin lens reflex or TLR. The first, objective, lens is for exposing the film. The second lens is for the viewfinder system and has a reflex mirror that projects the image on to a focusing screen — this provides *almost* exactly the same image as the objective (but can't because it is offset). TLRs typically employed leaf shutters and enabled continuous viewing and focusing during exposure. Being mechanically simple, they were not expensive to manufacture.

Image courtesy of Juhanson via Wikipedia (tinyurl.com/yykxzjak)

The second solution is to use only a single lens that incorporated a mirror box to view through the lens and so allow framing and focusing. This is the single-lens reflex or SLR. The first camera to employ a pentaprism viewfinder arrangement was the Zeiss Ikon Contax S in 1949. A pentaprism, in combination with the mirror, enables an image to be formed in the viewfinder as the photographer sees it, solving a major problem with SLRs prior to this. Pentamirrors offered a lighter setup but lost significantly more light through the optical path. The vast majority of SLRs used a focal plane shutter, although leaf shutters have been incorporated notably in to the medium format systems of Hasselblad and Bronica. Whilst SLRs solve the WYSIWYG problem, they make the camera larger, heavier, and mechanically more complex. The mirror system blanks the viewfinder during an exposure, limits the fastest shutter speed, and can introduce vibration during exposure.

Image courtesy of Jeff Dean via Wikipedia (tinyurl.com/y3e5zj8l)

The third and final solution is a direct result of digital cameras and that is to send the image recorded by the sensor directly to the electronic viewfinder or screen and is known as a mirrorless camera (because it removes the mirror box). This is a genuinely good solution as you can make the camera smaller, lighter, more reliable, and (potentially) cheaper. Early incarnations suffered from poor contrast focusing but this has largely been solved through the use of on sensor phase detection. The ability to see the live image means focus aids such as zebra patterning and focus peaking are possible, along with real-time exposure and depth-of-field. The trade-off is that the camera has a much greater reliance on electronic systems which means increased power consumption. As the mirrorless bandwagon really starts to take-off, camera manufacturers are reliving the CD boon years of the music industry. Yes, we have had a format change which means large swathes of photographers are buying their lenses all over again!

TONY RAY-JONES

Tony Ray-Jones was a British photographer who firmly sat within the documentary genre, but began his education (like many of his UK contemporaries) at the London School of Printing where he studied graphic design. But it was a scholarship to Yale (aged 19), on the strength of his photography, that flipped him more toward the artistic use of photos. It perhaps seems strange that documentary photography and art can be close-knit bed fellows but this was something Ray-Jones pursued, although today we might categorize him more in the vein of street work.

It's important to remember that this was 1960s America with the likes of William Egglestone, Gary Winogrand, Vivian Maier, Robert Frank, Diane Arbus, Helmut Newton, Robert Mapplethorpe, the Family of Man exhibition, and Elliott Erwitt to name a few. It was also a time of the cold war, the Bay of Pigs, the space race, and a public that gorged off the visual feast presented to it by the likes of Life and Harper's Bazaar. The old guard had given way to post-war prosperity and a new swathe of envisioning young photographers seized the photographic opportunities and developed them further. The 'decisive moment' of Cartier-Bresson had been replaced by the 'every moment' of Winogrand.

This was the thrilling environment that Ray-Jones found himself parachuted in to which began a prolific decade of photography. During his undergrad years he visited Alexey Broidovitch's (of Harper's Bazaar) Design Lab and got to know a number of street photographers such as Joel Meyerowitz who developed his interests. Graduating in 1964 he returned to a

markedly different UK where there was a distinct lack of interest in non-commercial photography. Using his street photography skills he began documenting the 'Englishness' of everyday people, however it was his ability to get in to the 'realness' of the subject using ironic humour that was new and inventive. He carved out, and exploited, a niche which had largely been ignored. Often described as a social-anthropologist, he again showed that providing a viewer with a new way of seeing the world creates success... incorporating humour doubly so.

Contracts, finances, and life led to Ray-Jones returning to the U.S. in 1971, however he was diagnosed with leukaemia in 1972 and died shortly after returning to the UK for treatment aged 31. His book, A Day Off, was published posthumously. Take a look at his photos as they might just delight.

❄ ❄ ❄

Beyond The Cut

Other Rs that didn't make the cut include radiography, rayograph, reflector, Oscar Reijlander, reportage, resolution, retouching, RGB, radio trigger, Leni Riefenstahl, Alexander Rodchenko, Rollieflex, Royal Photographic Society, Rule of Thirds, Red Shift, Redscale, repoussoir, Ruh Kitsch, Ricoh, Rodenstock, Ruth Synder (image), Raising the Flag on Iwo Jima (image), and Raising a Flag Over the Reichstag (image).

MIKE J. SMITH

S

SHOOTING SEX

With 176 13x11" glossy pages, Shooting Sex is the eponymous semi-autobiographical work of Bob Carlos Clarke. This weighty hardcover tome is about how to shoot on the theme of sex rather than sex itself (or, as the subtitle goes, 'the definitive guide to undressing beautiful strangers.'). The art world shows over and over again that the thought of sex sells, and has remained a stalwart of photographers as we've seen with the work of Paul Outerbridge and Helmut Newton. In fact, Bob Clarke has been referred to as the British Helmut Newton. Clarke notes that

> *Eroticism relies upon a finely tuned conspiracy between the eye and the imagination.*

Born in Ireland in 1950, he moved to a number of English public schools before finally finding his niche with photography, completing an MA from the Royal College of Art in 1975. It was during his time that he began photographing nudes, initially his fellow students, before moving on to models and strangers, selling the work to the likes of Men Only and Club International. This led to his introduction to latex and, specifically, shooting women clad in it. As he would write in Shooting Sex:

> *I devoted the following decade to shooting women in high heels and got myself thoroughly rubber-stamped with a reputation that became something of an embarrassment a decade later when pink-rubber party dresses became synonymous with bottle-blonde bimbos and provincial sex shops.*

While, in essence, he shot the fetish scene, he was not part of it. His fascination with latex perhaps reflects society more widely when he said:

> *[It] was the way it contained a body, concealing imperfections and defining contours beneath a gleaming synthetic skin.*

Not shy to be provocative, this perhaps touches upon the commercial draw of that thin line between erotica and soft porn. There's no doubting that Clarke stretched the boundaries of latex in the mainstream and was particularly adroit in its use. His iconic shots 'Fantasy Females Are Impossible To Satisfy' and 'Adult Females Attack Without Provocation' were defining in their genre.

Clarke most definitely had a way with words, possibly a closet writer whose out-pourings came visually; he was witty, sarcastic, self-deprecating, and painfully honest. So, Shooting Sex not only tells his life in tableau, it is also a technical guide to the subject. He was known for his indiscretions and was pretty direct on this point:

> *Photographers don't to have to sleep with their models, but it helps.*

Likewise, he was known for his close affinity to photography as an art form, seeing those ideas come to fruition in the darkroom.

> *The heart of photography is its ability to capture an irretrievable and unrepeatable moment in time. This is what makes it unique and more relevant to our daily lives than any other visual medium.*

On studio technique:

If daylight is an all-powerful goddess, flash is a wanton bitch who likes it rough. Dress her up in garishly coloured gels, force her into all the darkest, dingiest places, bounce her off walls and floors, and she'll love you for it.

However, Clarke's ability went much wider. His photographs for celebrity chef Marco Pierre White's book 'White Heat' are generally credited with inventing the genre. Shooting Sex also talks about the fashion industry, so that, when seeing a downturn resulting from his reputation, he commented:

At every level, this business is riddled with bullshit and bigotry. The only way to tackle it is to turn its weaknesses to your advantage. So, I changed my identity and began working under a pseudonym.

He also includes asides of encounters, meet-ups, and photo-shoots with the likes of Robert Mapplethorpe, Princess Diana, Rachel Weisz, and Keith Richards. Shooting Sex offers a fascinating insight in to the life and mind of one of the top fashion photographers of his generation. It will make you laugh, wince, cover your eyes, and quite possibly walk away insulted. Probably all of the reactions he wanted to elicit. Sadly, he also appears to have been a tortured soul, his wife describing him as *"entertaining, moody, and cruel."* As his success climaxed in the late 1990s, so his dissatisfaction increased. Maybe he sought meaning beyond the commercial aspects of his work and the demands this placed upon him; however, shortly after checking himself out of the Priory Rehab Hospital for depression in March 2006, he committed suicide by jumping in front of a train. His work lives on as a reminder of the vision and tenaciousness he brought to photography; however, it's also a warning of the exacting demands of being an artist so strongly in the public eye. The toll can be high.

STRIP PHOTOGRAPHY

This title suggests a continuation of a theme, but actually it's what it says on the tin; namely photographing in strips where a 2D image is formed from a series of 1D strips exposed over time. The simplest way to capture a strip image is to take a panning shot of someone running; by rotating the camera in the direction of motion while exposing the frame, we reverse the sense of blur. That is, the camera moves relative to the static background (so blurs it), while remaining (relatively) static to the moving foreground and so freezes it. However, because of the movement of the camera, we essentially end up photographing strips.

The other main branch of photography that has used strip imaging is the panorama where the film camera is rotated while recording an image to enable a wide field of view. Surprisingly the strip panoramic camera dates to as early as 1843! Typically, this would utilize a lens that incorporated a slit aperture to expose a strip of film as the camera rotated.

Image copyright Mike Smith

Of course, the alternative to moving the camera is to move the film! The most common use of this method was for the photo finish in sports, where film is continuously fed through the camera and so, constantly exposed. This was initially developed in the 1930s; at that point, the fastest frame rates were 65 fps, which typically missed the instant at which the line was first crossed. And the sport which first used it? You guessed it, horse racing! As the film is continuously exposed, there is no 'frame' and so, no instant to miss. You were guaranteed to see when the line was first crossed. Of course, as the image below shows, this won't solve the problem of a genuine dead heat or triple dead heat as in this example! I still remember watching the Olympics in the 1980s and wondering why the runners looked so weird in the photo finish images; it's because they were using a strip camera! George Silk famously used and popularized strip cameras for sports shots in Life magazine starting with the 1960s U.S. tryouts for the Olympics.

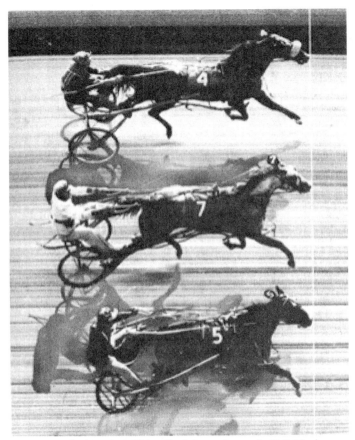

Image courtesy Cgoodwin, via Wikipedia (tinyurl.com/y4976fvg)

Digital cameras work inherently differently, as, unlike their film based counterparts, they tend not to have a global shutter. Or rather, the CMOS sensor electronics read the image a line at a time (like a strip camera), and this limits the maximum shutter speed achievable (typically 1/30th second) before artefacts are introduced from the rolling shutter effect. The classic example is photographing a rotating propeller. Mutations of the digital camera approach include the digital line scanner, which is a 1D CCD array. Panoscan made a range of line scanning panoramic cameras.

One variation on the strip image, which falls generally within

the genre, is the production of 'day to night' images that blend a 24 hour period. While there have been scientific uses of extracting a single column of pixels, day to night scenes are more artistic in their blending of scenes. Photographer Stephen Wilkes produces visually breath-taking images.

* * *

Beyond The Cut

Other Ss that didn't make it include Sallie Gardner at a Gallop (image), Surgeon's Photograph (image), St Paul's Survives (image), Stephan Filipovic (image), Soiling of Old Glory (image), Situation Room (image), silhouettes, stereographic photography, speed booster, satellite image, selective color, shallow focus, soft focus, star trails, stopping down, street photography, Sunny 16 rule, Sabattier effect, Sabastiao Salgado, salted paper print, Pentti Sammallahti, saturation, selfie, semiotics, sensitized plate, sequence, series, Andrew Serrano, David 'Chim' Seymour, Cindy Sherman, Charles Sheeler, shutter, Stephen Shore, silver process, Aaron Siskind, slide film, SLR, Eugene W Smith, snapshot, Earl Snowdon, Societe Francaise de Photographie, Societe Heliographique, solarization, Susan Sontag, Edward Steichen, Alfred Steiglitz, still-life, stop bath, straight photography, Paul Strand, studio, subtractive process, Jozef Sudek, surrealism, John Szarkowski, the Sharp JSH04, Samsung, Sony, Samsung, Sigma, Sinar, Sanyo, Silverfast, and Skylum.

MIKE J. SMITH

TILT-SHIFT PHOTOGRAPHY

Is there something so inherent to the design of the camera, yet so alien, so distant from its original form, that we take it for granted? It's placing the lens parallel to the image plane, centering it upon the middle of the sensor. Take a look at the camera below that dates to the 1850s — not a screw mount in sight. You have a light proof box that takes the dark slide (holding the light sensitized 'film'), to which is attached light proof bellows fronted by a lens mount, to which a lens slides in (not too dissimilar to how we use filter attachments today).

In modern cameras we typically are only able to change the distance between the image plane and lens — the focal length. Yet the amount of movement of the lens relative to the image plane is phenomenal breaking down to the three axes of rotation (up-down, side-to-side, around), plus movement of the lens itself up-down and left-right. The former is what we call tilting and the latter shifting.

Images courtesy of Nabokov via Wikipedia (tinyurl.com/y2oz6ze6)

Tilt-shift likely developed out of the experimental nature of early photography and the desire to change focal length using simple lenses. However, the introduction of handheld cameras largely set the tone for the mass produced market, although view cameras continued to use traditional designs. It wasn't until the 1960s that dedicated SLR lenses catering for tilt-shift appeared.

What does tilting and shifting actually do to the image as recorded on the sensor? Tilting has the effect of controlling the Plane-of-Focus (PoF). In a standard configuration this is parallel to the image plane (and lens plane) and is something so fundamental that, visually, it has become imprinted in our psyche. Tilting the lens allows us to move the PoF to any orientation in the scene. When they cease to be parallel, the three planes (PoF, image plane, lens plane) conceptually intersect at a common point. This is called the Scheimpflug Principle and understand-

ing it allows you to visualize where the PoF lies. If you tilt the lens *toward* your subject the PoF increasingly becomes aligned parallel to it. If you tilt the lens *away* from your subject the PoF increasingly intersects it (eventually at right angles). Once you have tilt, then changing focus also tilts the PoF so you need to work both together and it's important to remember that the depth-of-field is actually wedge shaped rather than fixed.

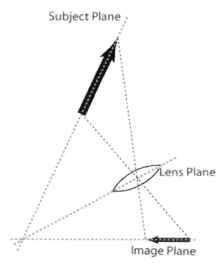

Image courtesy Phil Hunter via Wikipedia (tinyurl.com/y2pfuggg)

Portrait photographers have exploited this to create highly distinctive images which align the PoF with aspects of their scene. For example, Greg Heisler shot the cover of Time for their 'Person of the Year' that had Bono and Bill and Melinda Gates. For this he used a tilt-shift lens to maintain the PoF across the faces.

Where you swing the PoF *across* the subject (rather than aligned to it) you can create fake miniature scenes. These mimic the optical principle of the shallow depth-of-field we associate with photographing miniature scenes, allowing us to fake it for the real world. You can also do this digitally in post-production, but it's way more fun to swing your lens the other way and use a

tilt-shift!

Shift movements adjust the field-of-view up-down and left-right however to achieve this, the lens must have a larger than normal image circle. When used with wider angle lenses, small shifts can significantly alter what appears in the image. The key application has been in architectural photography where cameras need to be tilted upwards to photograph buildings — as there are shape distortions (and so converging vertical lines) if objects are not parallel to the image plane, buildings are not rendered faithfully. Shifting largely solves this problem.

Tilt-shift lenses are relatively expensive in comparison to their same-focal length counterparts, however If you haven't rented one for the weekend why not give it a go? You might just discover what a fantastic aid to creativity they can be.

Image via Wikipedia, in the Public Domain (tinyurl.com/yykxm7mg)

TRAIN WRECK AT MONTPARNASSE STATION

It's a photographic truth that if you shoot anything weird, shocking, or unusual it will be popular. News and fashion play strongly to this premise. Diane Arbus was accused of populating her portfolio with a 'freak show', whilst some travel 'togs push the theme of 'poverty porn'. Ironically the work of August Sander was some of the most boring around because...well, because it wasn't interesting! But viewing it now through the intervening 90 years of history flips this on its head and the reason for its blandness now makes it interesting!

What has this got to do with trains and the Montparnasse Station in Paris? The title is a giveaway as it's a train wreck, however to misquote George Orwell, "*not all train wrecks are created equal.*" This is spectacular by its unusualness — I can't say I have seen a train standing vertically on its nose before, having exited the station through the ticket hall. The very scene invites narrative to accompany it as it starts a story and we want to know the ending. This is not to belittle the tragedy that the scene implies and the potential for human loss. Coming in to a terminus station, we assume it was a passenger train and, indeed, there were 131 passengers on board. It also speaks to a capital city and the busy, bustling, daily lives that its residents on the street below led.

Tragedy is newsworthy for two reasons. Firstly, in the sense that

we want to read about events that happen in our world. We gape and gawp, crowd around, and, in our modern world, live stream it. We might see this behaviour as reprehensible but universally we are transfixed by tragedy and, as Avenue Q explains with the song Schadenfreude, there might even be pleasure in someone else's pain. How much empathy we feel for others will be born and bred into us. The next time you view a photographic scene of tragedy, ask yourself how much of the pain and sadness you feel for those in the photo?

The second reason is that it is vital to consume these events as a society, responding to them collectively. Our first response might be to grieve for those involved — in the UK, the mass out-pouring of emotion after Princess Diana died was unique. This may then be followed by remedial action where the public de-cries an outcome and demands the intervention of politicians: the Paddington train derailment led to a change in safety pro-cedures, whilst the Christchurch mass shooting to a change in gun laws.

So, what is the story in this photo? This is the Granville to Paris Express comprised of a loco, three luggage vans, a post van, and six passenger cars which was due to arrive shortly be-fore 4pm on 22 October 1895. Running a few minutes late, the driver entered the station too rapidly, trying to make up for lost time. The air brake on the engine failed and the locomo-tive ran through the buffer stop, across the concourse, and fell on to the Place de Rennes below. Remarkably only one person was killed, a pedestrian in the street. The loco remained in place for two days whilst due process was followed, at which point it was winched back into the station and repaired! The driver was fined 50 francs, equivalent to about $1,500 today.

* * *

Beyond The Cut

Other Ts that didn't make the cut include Tamron, Tiffen, Tokina, Topcon, Tamrak, Think Tank, Trigger Trap, time lapse, John Thompson, tableau, William Fox Talbot, Mario Testino, TIFF, tintype, toning, travel photography, The Steerage (image), Toffs and Toughs (image), Thích Quảng Đức Self-Immolation (image), Tennis Girl (image), Tank Man (image), Taking a Stand in Baton Rouge (image), and the Tydings Affair.

U

ULTIMATE CONFRONTATION

Picture the historical setting — your government, which stands for law and order, of setting a high legal and moral standard, is involved in illicit and illegal activity, of perverting moral and legal codes, of practice that has taken the lives of its own citizens as well foreign nationals. The issue has become of such national significance that it has mobilized people across political and social divides, uniting them to a common cause of protest. Only by sustained pressure on political powers and direct action can change be effected.

If this sounds familiar then it is because governments across the world have, and continue, to abuse the power that is invested in them by their people. As psychologist Philip Zimbardo notes, responsibility without oversight leads to the abuse of power. It is a difficult line to travel, but leaders need the flexibility to enact change without the opportunity to abuse that position unseen and unchallenged. In short, we need the traditional strengths of honesty, trustworthiness, and empathy. Attributes which often seem to be in short supply with national leaders.

Which brings us to 'Ultimate Confrontation', shot by French photojournalist Marc Riboud on 21 October 1967 during antiwar protests against the Vietnam War. Over 100,000 activists, brought together by the National Mobilization Committee to End the War in Vietnam, marched on the Pentagon. It is a classic shot that has oft been repeated, for example more recently in Baton Rouge where there were demonstrations against the shooting of Alton Sterling and in Tiananmen Square with Tank

Man.

What makes this image so powerful are the subjects and their juxtaposition. We have the soldiers, with a hint of youthfulness, in the service of their country, following orders. The rifles are a symbol of control, however it is the bayonets that draw the eye. There is something primal about a blade and the way it savagely weaponizes the scene. Opposing them is a single child holding a chrysanthemum. Jan Rose Kasmir was a 17 year old American high-school student and is the icon of flower-power innocence. The framing is immaculate because it is so tight with background paraphernalia lost in bokeh. In fact, the tightness makes individual soldiers unidentifiable — they simply become 'soldiers', no longer individuals, but agents of the state. More than the framing, the moment is clearly important. It is an instant in time captured in perpetuity, however we must remember that there is a temporal complexity to understanding how the individuals acted and reacted as the protest developed. Speaking retrospectively, Kasmir says

The moment that Marc snapped that picture, there is absolute sadness on my face because, at that moment, it was sympatica. At that moment, the whole rhetoric melted away. These were just young men. They could have been my date. They could have been my brother.

Many other images were shot during the protest, including 'Flower Power' by Bernie Boston, but they didn't quite capture the same emotive dynamic. We can all analyse a news photo to understand why it is iconic, but to actually take one is a little more nuanced. Sure, you've actually got to be there, but there is more to it than that. Riboud might have thought through some aspects such as framing, however I wonder how much was experience and how much was luck. To get more experience you simply have to get out there and shoot more. A lot more. And to get luckier? Get out there more!

Image courtesy of the Kheel Center via flickr (tinyurl.com/y3fjkdhy)

UMBO

Otto Umbehr, or Umbo, was a German photo journalist who worked from the 1920s onwards and was one of the foremost modernist photographers of the period. Initially trainedg as a painter at the highly influential Staatliches Bauhaus (or simply Bauhaus), he was expelled and lived in poverty in Berlin. He was subsequently gifted a camera by his friend Paul Citroen, which became a major pivot point in his life. His portraits and urban scenes gained him a reputation as an avant-garde photographer and in 1926 he set up a studio, as well as joining the Dephot photojournalist agency in 1928 (which later closed when the Nazis came to power in 1933).

His work unusually combines close-up, filmstyle and Bauhaus-style panel pictures. Atmospherically, the modernist approach feels similar to the work of Paul Outerbridge, equally surreal, imaginative, and refreshing. His street work involved montage and unusual angles which, when combined with the bohemian society of the Weimar, provide a familiar yet distant view on another society in another time. Umbo plays with the viewer psychologically, mixing how we see things with how we understand them, making his images more than the sum of their parts. He experimented with fish-eye lenses and x-ray film amongst others.

Up to and during World War 2 he was a photojournalist working for Signal and latterly a driver. Sadly, most of his archive, around 60,000 negatives, was destroyed by bombing in Berlin. Whilst much of the original material is permanently lost, the remainder of his complete work is now in public ownership, preserved by three German museums (Berlinische Galerie,

Sprengel Museum, and the Bauhaus Dessau). It is also typically photographic that, after the war, he tried to resume his career, unsuccessfully. In 1958 he ended his creative outputs and took on a range of low paid work to supplement his income, although continued to teach. It was only in the late-1970s, shortly before his death in Hanover in May 1980, that a major retrospective was organised and he saw some profit from his hugely influential pre-war work.

<div align="center">❊ ❊ ❊</div>

Beyond The Cut

Other Us that didn't make the cut include underwater photography.

BENJAMIN VON WONG

If you've come across Benjamin Von Wong's BTS videos (behind-the-scenes) then you will appreciate his fantastical images. Von Wong actually trained as a mining engineer in Montreal, hooked in by the sales pitch for a well-paid job, before then working for several years in some fairly out of the way places. The pivot point in his life that led him to buying a camera was splitting up with his then girlfriend. After an intense period of shooting and learning from his mistakes, his first break was event photography.

It was during this period that he became interested in developing 'set pieces' that were fantastic, mind boggling, epic, and intended to be overtly sumptuous and stunning. In short, the seed for Von Wong, as his brand was to become, was sown. As his images became popular, so Von Wong was able to up-the-ante and produce more impressive effects. There was no income generation, rather this was about creating visceral scenes purely for the sake of it.

Image copyright Benjamin Von Wong

Image copyright Benjamin Von Wong

Posting his collaborative work garnered larger numbers of followers on social media, however it was the production of BTS videos that caused interest to spike. Producing stunning imagery is attention grabbing — showing people how you did it leads to a large community of engaged followers and increased the number of people wanting to collaborate on new projects.

In terms of social media, Von Wong thinks he was part of the lucky generation that was at the nexus of the smartphone-so-

cial media wave that swept the world as people moved to 24/7 connectivity and a life-lived that was always online. However, he warns that this is a constantly shifting market and whilst there is some level of best practice (be regular, be consistent, be timely), you cannot reproduce those past successes today.

By the time 2012 came around, Von Wong had reached a tipping point; mine engineering wasn't a passion so he quit his job and funded a trip to Europe, offering workshops along the way. This became a modus operandi, with Von Wong in search of the viral hit, an image that would catapult him in front of global audiences. It came in the form of 'An Underwater Shipwreck' whilst he was on holiday in Bali and led him to tying his models to a shipwreck in order to photograph them! The exposure from this shoot landed him squarely in front of large brands, garnering him his first major commercial job for Huawei using their then new P8.

Don't think for a minute that everything a successful photographer produces is stunningly successful. Von Wong is open about this and whilst he sets his standards high, he doesn't shy away from the material he has posted. As he lives and breathers social media, so you can look at his entire post-history on Flickr. It is open and honest, and allows you to see how one commercial photographer has developed. Von Wong says that photos (and photo shoots) aren't successes or failures as it isn't a binary split. Projects have a range of different elements to consider — sure, the photo itself, but then the lighting and the model, as well as the message to convey. Von Wong has posted images of a failed project that never launched because the messaging was wrong, even though the shoot itself was a success.

Success breeds success and Von Wong receives a varied number of commercial projects, however he stays grounded by keeping this at 10-20% of his output, the remainder coming from collaborative or philanthropic projects. He has turned his hand to campaigning for the environment, with projects such as 'Mermaids Hate Plastic' and 'Climate Change Doesn't Care.' He

has a long-standing interest in the environment and doesn't see himself so much as an environmentalist, as someone overtly conscious of the world he lives in. He also takes on highly personal projects such as 'How to make a viral fundraiser' where he produced a video which helped raise over $900,000 for 4-year-old Eliza O'Neill who suffered from a degenerative brain disease.

Von Wong principally works in-camera and whilst he has used compositing, he loves traveling, meeting people, and just generally doing amazing stuff! Part of what makes the job enjoyable for him is not sitting in front of a computer, however he is keen to scale his activities and one of his measures for success is *impact*. As a result, he is looking to actively encourage and bring *"creatives in to the impact space."* Specifically, to *"empower others to find meaning in the work that they do"*.

As part of this, he has created a series of 'creative nuggets' on Instagram which are daily posts looking at all stages of the creative process. We all want a life well lived and it is something we can strive to achieve. Still, there is no excuse not to have an impact upon society — we are all part of the world we live in, so take a leaf out of Von Wong's book and make it a better place.

VIVITAR

The name Vivitar sounds like a German lens brand produced by Leica or Zeiss... or possibly a Japanese manufacturer of high quality glass. Indeed, I would be surprised if there wasn't a film photographer who hasn't, at some point in their life, owned a Vivitar product. So, what is their story?

Vivitar was actually founded in Santa Monica, California, in 1938 by Max Ponder and John Best, originally called ... 'Ponder and Best!' They initially imported German photographic equipment, expanding to a range of Japanese brands post-war. They introduced the U.S. market to Olympus, Mamiya, Rollei, and Voightlander amongst others, however in 1964 they lost the distribution rights to Olympus and Rollei which meant coming up with a new game plan. In true entrepreneurial style, they created their own brand and rebadged the equipment they sold. Yet their understanding of the camera market went deeper — they appreciated that third party lenses could be made cheaper than OEMs and, if sold in large enough numbers, profit margins would be respectable. Vivitar built a reputation for good quality lenses at modest prices. They upped-the-ante in the early 1970s by commissioning manufacturers to produce lenses to their own design, the Vivitar Series 1. They also produced a range of 35mm cameras manufactured by Cosina, as well as a highly acclaimed series of strobes. Vivitar eventually became a large multinational with a number of national subsidiaries

In 1985 it was bought by Hanimex, hitting annual sales of $100M, however this was the high point. Vivitar was sold to Gestetner in 1990 and moved away from lenses and flashes, to the high volume point-and-shoot market. The company subse-

quently went through a range of sales, with the brand name eventually being sold as part of bankruptcy proceedings to Sakar International in 2008. Salkar didn't want the stock which was sold in a huge online auction!

As is often the case in business, it was a sad end to an innovative company.

* * *

Beyond The Cut

Other Vs that didn't make the cut include Willard Van Dyke, vintage print, Vogue, vorticism, Vu, Velbon, vignette, View form the Window at Le Gras (image), Valley of the Shadow of Death (image), VJ Day in Times Square (image), vignette, Voightlander, and VSCO.

MIKE J. SMITH

WEEGEE

New York press photographer Weegee assumed near mythical status because of his uncanny ability to be the first on a news scene, along with his unflinching tabloid images depicting crime, injury, and death in Manhattan's Lower East Side.

Born Ascher (later Anglicized to Arthur) Fellig in 1899 (Zolochiv, Ukraine), his family emigrated to New York in 1909. After a variety of street jobs, he joined the Acme Newsroom as a darkroom technician and this is possibly the original source of his pseudonym — Squeegee Boy. The name was later transcribed in to Weegee — a phonetic spelling of ouija — referencing his unnatural ability to be at a news scene before the police!

In 1935 he went freelance having spent a decade in the darkroom. This likely contributed to his style because he would have seen front-page negatives come in — he saw those scenes that made the greatest impact, and so earned the highest income. To be better than the photographers whose images he processed he needed to pick the best stories and be the first there. As he said:

> *What I did simply was this: I went down to Manhattan Police Headquarters and for two years I worked without a police card or any kind of credentials. When a story came over a police teletype, I would go to it. The idea was I sold the pictures to the newspapers. And naturally, I picked a story that meant something*

During the 1930s and 40s New York was a treasure trove for a photographer seeking the most grotesque of images to splash

across the front pages of the leading papers of the day. In 1938 he became the first photographer licensed to use a police-band shortwave radio, significantly increasing his ability to cover a range of stories. His 'brand' spread wider with MoMA acquiring a number of his photos in 1943, as well as lecturing at the New School for Social Research and editorial assignments for Life and Vogue. Naked City was his first photo book, a searing insight in to the tragedies and afflictions of the New York underbelly. More than that, it shows what New Yorkers wanted to read about. The title and aesthetic were subsequently used in the 1946 movie 'Naked City'. The pull of Hollywood drew Weegee westward where he worked as an actor and consultant through to the 1960s, including reprising himself in the exploitation movie 'The Imp'probable Mr Wee Gee.'

It was during this period that he experimented with image distortion and montage, as well as traveling extensively throughout Europe. In 1957 he developed diabetes, moving in with his friend Wilma Wilcox who helped look after him until his death in 1968. She was bequeathed his archive of 16,000 photos and 7,000 negatives which were subsequently given to the International Center of Photography.

He worked with a standard Graflex 4x5 Speed Graphic, common amongst press photographers. This was a large, handheld camera, first manufactured in 1912 (through to 1973). It featured a focal plane shutter capable of 1/1000 sec exposures and could take a take a range of sheet film up to 5x7, with later models adaptable to take 120 and 220 roll film.

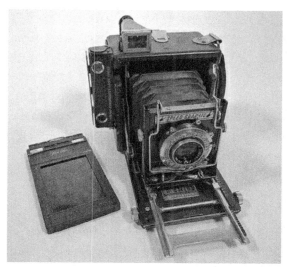

Image courtesy of David, via Wikipedia (tinyurl.com/y3k8mna2)

The Speed Graphic was slow to use, in the style of a traditional large format camera. The photographer changed the film holder, opened the lens shutter, before cocking the focal plane shutter. The dark slide was then removed from the film holder, the lens focused, and the focal plane shutter released. If the flashbulb was set, this was fired, and then needed to be replaced. Fellig's initial model was likely the Pre-Anniversary 4x5, possibly using the Grafmatic Film Holder which held six sheets of film.

Weegee is generally credited with the saying

f/8 and be there

which is beloved of (35mm) news photographers worldwide because it balances the competing factors of depth-of-field and exposure. If you go with f/8 and use zone focusing (or the hyperfocal distance), then you can 'concentrate on the moment' in order to capture the photo. Except he probably didn't say it! He *did* preset the camera which would have been required for fast technique under testing conditions. Low light, rapid ac-

tion, and a slow camera led him to use f/16, 1/200 sec, and 10 ft. It's worth remembering that he used large format 4x5 film, which would mean f/16 was fairly open and equivalent to a full frame f/5.6. Unsurprisingly then, he went for a fast aperture, flash, and precise focusing, something he proved to be adept at.

So, what of his work? What I like about Naked City is the warts-and-all approach to the daily life of New Yorkers, along with Weegee's informal introductions that begin each of the themed sections. These can segue from the smiling faces of a mother and daughter, to the motionless wrapped bodies from a tenement fire, before showing a face-down corpse, pistol an arms-reach away, then the jovial frivolity of a dance. Contrary to what you think you might know about Weegee, his corpus was about public life (and the not so public) and he displays it to the max. It is wide ranging, with the tragic only one part of it. What is noticeable when you look through the book is that, to an extent, it is like flicking through a newspaper. However, pause and stop to look at a few images — Weegee is a master in capturing the moment, delivering a story, and engaging the viewer. To shoot even one of his images would make you feel accomplished. To shoot a whole book? That takes an accomplished career. Give Weegee a moment... he might just surprise you.

WET PLATE COLLODION

The 1840s saw the dawn of photography through the competing technologies of the Daguerrotype and Calotype. The first offered a remarkably high fidelity positive on a glass base but no option for reproduction, whilst the latter produced a translucent negative on a paper base that could be easily contact printed but was of relatively low resolution.

The answer was the creation of a negative on a glass base and this came in the form of collodion, a syrupy solution of pyroxylin in ether and alcohol. Discovered by Frederick Scott Archer in 1848, it involved dissolving gun cotton in ether/alcohol and then pouring it on a clean glass plate to coat it. Once tack dry (set), it was taken in to the darkroom and dipped in silver nitrate for sensitization before placing it in a film holder with the dark slide added. The plate was then exposed in the camera, before developing, washing, and fixing onsite.

The plate was an order of magnitude more sensitive than existing processes, reducing exposure times to a matter of seconds. Though the above steps highlight the single biggest disadvantage — the entire process needed to be completed in under 10 minutes which meant carrying a portable darkroom. This didn't stop photographers using the process widely, such as travel photographer John Thompson and aeronaut Nader who worked from a hot air balloon! The image below is thought to be the largest wet plate negative created measuring a remarkable 160x96cm, taken by Charles Bayliss.

Image courtesy of State Library of New South Wales via Wikipedia (tinyurl.com/y64xgg95)

Further chemical experimentation to find a dry collodion process was not entirely successful as it essentially involved slowing the drying time at the expense of sensitivity. Collodion remained the pre-dominant process through to the 1880s, however it was the development of the gelatin based dry plate process in the 1870s that paved the way for a step change in photography, accelerating to the production of nitrate film in 1889 and the Leica 35mm camera in 1913. The rest is history.

* * *

Beyond The Cut

Other Ws that didn't cut the mustard include Wait for Me Daddy (image), Whipped Peter (image), Warsaw Ghetto Boy (imager), White Sands Rocket (image), war photography, Carleton Eugene Watkins, Edward Weston, Minor White, Art Wolfe, Wratten, Andy Warhol, Garry Winogrand, and Wray.

X-TRANS SENSOR

Camera sensors count photons and the image you see on the screen is simply a representation of those pixel counts. For a black and white JPEG, each pixel contains an 8-bit number that ranges from 0 to 255. If the scene goes from black to white, then the grey value is simply scaled by this number: 0 for black, 255 for white and mid-grey at 128. Other than specialist cameras such as the Leica Monochrom, digital images are colour yet there is only one sensor and it can only record one number per pixel. How then does it achieve a full colour RGB value? The answer is through the use of a colour filter array (CFA) and a little mathematical machination.

Digital sensors are broadly sensitive to visible light, a bit like a black and white film. By placing a filter array over the sensor, each individual pixel records only red, green, or blue light. The process of de-mosaicing separates the samples of red, green, and blue pixels in to individual layers and interpolates (aka estimates) full RGB values at each pixel. Not surprisingly, the algorithms used to de-mosaic range from relatively simple to complex.

The sampling regime used in the CFA is crucial to producing a high-quality image and this is commonly the Bayer array, created by Bryce Bayer of Kodak in 1976. It uses a repeating 2x2 block arrangement that is 50% green and 25% red/blue respectively. Daylight perception of the human eye has greater sensitivity to luminance and so green light. Ultimately, a better looking green layer should create a better-looking image.

Image courtesy of Cburnett via Wikipedia (tinyurl.com/y3xoep2k)

And so to Fuji's X-Trans APS-C sensor. What was unusual about Fuji's first X-series interchangeable lens camera, the X-Pro1, was it's use of a new sensor and, specifically, a new CFA. Fuji does have their own semiconductor business and has also worked in close partnership with Toshiba, however the world of sensor fabrication is opaque to say the least. Regardless of which exact sensor is used, at some stage fabrication involves the overlay of their own-designed CFA.

Fuji make great fanfare of the unique advantages that the X-Trans CFA can bring. It uses a 6x6 less-regular repeating array, than Bayer's 2x2. The latter's regular arrangement can suffer from interference patterns leading to moiré. The solution is typically a low pass filter; but this is at the expense of a loss of effective resolution. The Bayer array also has columns and rows with no blue or red photosites which can lead to false colour.

Image courtesy of LiamUK via Wikipedia (tinyurl.com/yx9hcs3j)

In short, Fuji (and many photographers) believes that, compared to otherwise equivalent sensors, the X-Trans should be sharper and have better colour reproduction. Fuji thinks that this makes the APS-C sensor as effective as full frame sensors in competing cameras. This remains to be seen and is largely untested principally because DXOMark's testing suite doesn't support it.

The main drawback of X-Trans sensors (other than their APS-C size) has been the lack of software support for de-mosaicing, with early versions of Lightroom and Bridge particularly poor. There is also a computational overhead which affects both PC and in-camera processing. Even with better raw conversion, algorithms that work well with Bayer array sensors (which is where development is focused) may not work as effectively with X-Trans.

Fuji continues to use X-Trans in its X-series cameras, excluding the entry level X-A models, however they use a traditional Bayer sensor in their medium format offerings. Fuji remain committed to X-Trans for the time being so it will be interesting to see how the format develops.

XIAOXIAO XU

Upcoming Chinese photographer Xiaoxiao Xu spent the first 15 years of her life in China before emigrating with her family to the Netherlands. Since then she has held a fascination for photographing her homeland in a documentary style, contemplative in nature, as if looking in from the outside.

I am reminded of Sting's track 'Englishmen in New York' where he sings *"I'm an alien, I'm a legal alien."* Xu's photos show a sense of the familiar, yet still wanting to identify with, and understand, what the camera shows. For her graduation work at the Photo Academy in Amsterdam she travelled back to her hometown of Wenzhou. She says of this

> *I think that is when I began to tell stories, in this case, telling my own story, a story about homesickness, melancholy, and about how a rapidly changing city differs from the one in my memory*

Image courtesy of Xiaoxiao Xu

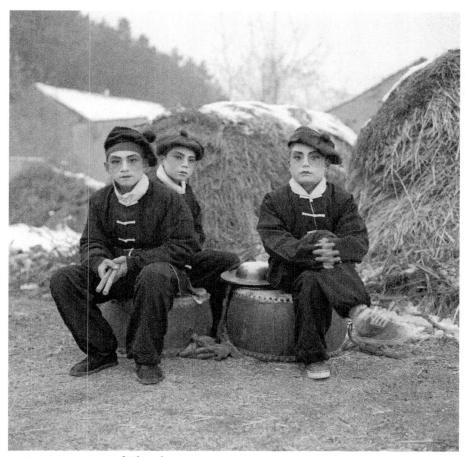

Image courtesy of Xiaoxiao Xu

Fifteen is a difficult age to be torn from a home of familiarity and friends, to find oneself in an alien land. Xu says she felt "*locked up*" and it was during this period that she found photography. Perhaps most emotively of all

photography allows me to crawl out of my shell and gave me a voice to express my feelings

For Xu, the curriculum at the Photo Academy enabled her to confront her memories, motives, and desires and how these impacted upon her artistic interests and 'aesthetic preferences'. However, it was the continual cycle of assignments and presen-

tations that forced her to go out in to the world, returning to present her understanding of it — "*to reveal my own vision of life and my environment.*" One photographer who impacted upon her during this period was Claude Cahun, the inveterate surrealist self-portraitist who was particularly active in the 1920s and 30s.

Xu started shooting with an entry level Canon DSLR, but during her degree switched to analogue, initially a Hasselblad, to which she has added a Mamiya 645, Mamiya 6x6, Holga, Yashica, and Fuji Mini Instax. Her favourite lens is a 50mm standard. Whilst many might associate documentary photography with black and white, not withstanding work such as Egglestone's, she purposefully shoots in colour because of its "*vividness and playfulness*" and it being "*closer to reality.*"

What is interesting about Xu's work is that she predominantly shoots in China, the land of her birth. Whilst many immigrants will photograph the country they settle in, possibly to help them understand their new home, Xu's images demonstrate a sense of fascination — a desire, a longing, to better know and understand her homeland. She says

I am alienated from the country but at the same time deeply attached to it

Perhaps this sense of separation is the result of the age at which she moved and so the inability to grow to adulthood, and integrate, with her native peers. This alienation may well be magnified with China. She says:

The madness and absurdity of China strengthened my fascination even more. The most impossible scenes happen... and yet the people live in harmony with it

'Aeronautics in the Backyard' was her breakout work which garnered considerable international interest. For this project she

visited eight farmer-aeronauts, living with them, interviewing them, and photographing them. In their spare time they have designed and built their own aircraft, some less successfully than others, bearing the visible scars. She believes the success of the project was *"because the subject is in its purest form about imagination and the pursuit of your dreams."* These are humble people and it touches upon their inner most desires. Whilst it may seem as if many of her images are posed, this is not something Xu sets out to do. She observes and if a 'pose' naturally presents itself she might ask them to hold it.

Her projects have taken the form of a road trip, such as 'Chinese Wall' where she travelled 25,000 km in three journeys. The logistics are far more complex in these scenarios and so, prior to each trip, she plans out the entire route. The schedule was tight, given the distance and desire to visit as many villages as possible. She was usually on the road from 7am to 7pm every day, stopping frequently to talk to locals. This is now forming the basis for her next photobook. And after that? *"I want to start a project about India."*

* * *

Beyond The Cut

Other Xs that didn't make the cut include xerography and Xn-View.

MIKE J. SMITH

YASHICA

Founded in Nagano, Japan, as Yashinma Seiki in 1949, it's eight employees began by making components for electronic clocks progressing to manufacturing its first camera, the Yashimaflex, by 1953. This was a 6x6 twin lens reflex that used lenses produced by the Tomioka Optical Works, a relationship that lasted many years. The Yashica subsidiary was formed in 1957, the same year as the release of its popular Yashica Mat TLR, growing to 2000 employees by 1958. The Yashica Pentamatic, a 35mm SLR, arrived in 1959 with a proprietary lens mount. This failed to gain popularity and so was redesigned to Zeiss Ikon's more popular M42 mount in 1962.

In 1965 they introduced the first commercially successful electronically controlled 35mm, eventually selling 8 million units. In 1968 they finally acquired their lens manufacturer — Tomioka — giving Yashica an enviable reputation for high quality camera electronics and optics. In 1968 they introduced the TL Electro-X, an SLR which incorporated in-camera metering. In 1973 they began a long-term collaboration with Zeiss Ikon, producing the Contax RTS that could take all Contax lenses using the C/Y mount. It was a commercial success. They then produced the lower cost Yashica FR which retained many of the same features. The practice of producing a high end Contax and lower cost Yashica continued for the next 10 years, marking a high point in the four-way race with Canon, Nikon, and Minolta.

In 1983 Yashica was acquired by Kyocera and continued production of both Yashica and Contax cameras.

Image courtesy of Ashley Pomeroy via Wikipedia (tinyurl.com/y4mtao7o)

Whilst Yashica had innovated extensively including features such as electromagnetic shutter release, full PASM exposure modes, and TTL flash, they were slow to jump on the autofocus bandwagon. Kyocera repositioned the company in the 1990s to point-and-shoot cameras, moving production from Japan. This was a race to the bottom, a mistake made by a number of companies around this time. All camera production was halted in 2005 and the trademarks sold in 2008.

If there is one thing I've learnt from reviewing the history of camera companies it is this — you are only as successful as your last model. The more product categories you have, the greater your capacity for success, whilst the bigger the company the greater the ability to withstand difficult times, but the harder it becomes to pivot. Yashica, Bronica, Fuji, Minolta, Kodak, and Leica are all abject lessons in how to pivot — or not. Also, how the success of one company can rescue the fortunes of another, as Minolta did with Leica, before being buried in a corporate sale to Sony. Or were they the foundation for the success of the mirrorless E-mount? Who knows what the future will hold and what the next successful pivot will be?

MADAME YEVONDE

Born in 1893, Yevonde Philone Cumbers grew upon a wealthy family and was educated at progressive boarding schools in England, France, and Belgium. Independent of nature, she joined the suffragette movement in 1910, but then moved on to a 3 year apprenticeship with society photographer Lallie Charles. This was a pivotal moment as she was heavily influenced by the success of Charles and her sister Rita Martin, subsequently setting up her own studio in 1914.

She used the classic marketing ploy of 'influence begets influence' by inviting well known figures to free portrait sittings. Her photos were widely printed (including the newly arrived Vogue and Harper's Bazaar), leading to a number of commercial commissions as well as photographing the likes of A.A. Milne, Noel Coward, Barbara Cartland, and Louis Mountbatten. Whereas Lallie used soft, diffuse, natural light to produce pictorial images popular at the time, Yevonde remained firmly contemporary in style, posing her subjects, styling off-camera gazes, along with the creative use of props. Indeed, she remained at the forefront of 'real' photography which can be seen paralleled in the works of Paul Outerbridge and the f/64 Group in California.

Perhaps her greatest legacy was the colour photography she created, a result of being an early adopter of the Vivex process which accounted for 90% of the UK market. Vivex used three negatives for the subtractive colours of cyan, magenta, and yellow. These needed to be exposed sequentially using a bespoke camera back or simultaneously using a Vivex camera. The three negatives were developed separately before being

printed one on another — this created problems with image registration but allowed the creative manipulation of colour.

In 1932 Madame Yevonde held her first exhibition of colour photos — remember that this was a period where colour was considered vulgar. The public reaction was positive which led to commercial commissions and she switched almost exclusively to colour. It was during this period that she created her highly acclaimed 'Goddesses' series that grew from portrait sittings for a high society ball, as well as receiving royal commissions which were as exclusive then as they are today.

In 1936 she travelled to New York to tout for work. Cunard subsequently commissioned her to photograph the artists and craftsmen working on the Queen Mary with all 12 submitted photos published in Fortune. The 1930s brought an untimely end to her colour work with the closure of the Vivex factory as war broke. In a similar manner to Outerbridge, she refused to transition to Kodachrome when the rest of the industry pivoted. She continued her studio business, now offering to visit clients as well as commercial commissions, well in to her 70s. A retrospective (see examples of her work at the Madame Yevonde Archive) was organised for her 80th birthday, marking 60 years as a professional photographer. She died at the age of 82, a life lived to her creed of

Be original or die

* * *

Beyond The Cut

Other Ys that weren't on the cards include Jose Yalenti and Yongnuo.

ZEISS

As photographers, we want a sharp image, aiming for tack sharp. Beyond this, there is Zeiss sharp. Held in similar reverence to Leica and originating from the same German smouldering pot of science, technology, and manufacturing, many photographers may have owned a Zeiss-branded product (lens cloth anyone?), but to get your paws on the real deal means investing some significant capital. For example, the high-end Otus 85mm f/1.4 retails for over €4,000. How did they get to their current multinational status with a turnover of €6B, employing 30,000 people, and working across industrial, consumer, medical, and semiconductor manufacturing sectors?

Founded in Jena, Germany, in 1846 by the optician Carl Zeiss to manufacture microscopes, Zeiss built an enviable reputation for high quality optics, producing their 1,000th microscope by 1866. In order to develop as a company, they needed to be more than a manufacturer, they needed to innovate. Early designs from Ernst Abbe were made possible by the establishment of the Zeiss glassworks by Otto Schott with optical properties ideally suited to lenses. Major innovation was undertaken by Paul Rudolph, who experimented with a range of optical solutions using cemented asymmetrical groups, producing influential product lines such as the Anastigmat, Protar, Protarlinse, and Tessar. The double-gauss design of the Planar lenses produced a fast f/3.5 model — remarkable for 1896.

Zeiss was also renowned for camera manufacturing with its Zeiss Ikon brand. It was formed in 1926 as a separate company under Zeiss (and funded by them) from the merger of Contessa-Nettel, Ernemann, Goerz, and Ica, making it one of the biggest

players in Dresden, the capital of photo technology. Using Zeiss lenses and shutters, the company continued production of existing products as well as developing new ones, with the Contax line being a major innovation. These were designed to compete directly with Leica (such as the 1936 Contax II below) for the professional market and, in many respects, were mechanically superior, introducing a faster brass shutter and exposure meter, along with new high quality optics and introduction of the M42 mount.

Body image courtesy of Rama via Wikipedia (tinyurl.com/y2tp2w8m)

If Zeiss was a complex business before World War 2, it became more so after it. Jena was occupied by the U.S. Army, which relocated parts of the Zeiss workforce to the Contessa factory in Stuttgart (as Zeiss Ikon) and Oberkocken (as Zeiss optical). The remainder, along with the factories in Dresden, fell in East Germany and initially came under the control of the USSR. All tooling was taken back to the Kiev factory (as reparations) for Soviet production, with Zeiss Jena then coming under state hands.

Zeiss (Oberkochen) continued making lenses for Ikon, but also other manufacturers, including Rollei and Hasselblad, the latter

notable for the highly acclaimed images of the moon landings. To the surprise of the industry, Ikon ceased camera production in 1972, beginning a long-lived licensing partnership with Yashica on the Contax brand that lasted until 2005, when new owners Kyocera pulled out of the camera market.

Unsurprisingly, there was continued dispute over the use of the Zeiss and Ikon names that continued until German reunification post-1989. At that point Zeiss Jena numbered some 70,000 workers, which diminished to around 30,000 by 1991. Reunification of the company followed, but in a more business-like manner: Zeiss bought the bits it wanted and left the rest! The microscopy division returned to Zeiss (along with about 10% of the workforce), the rest remaining.

Zeiss revived the Ikon in the form of a rangefinder with production by Cosina through to 2012. They have always been active in licensing their lens designs, including to Leica and more recently, Sony. However, for contemporary photographers, they are known for their high quality manual focus lenses offering the best optics available. Look at any recent lens reviews, and Zeiss is often at the top when it comes to sharpness. Beware that fast aperture, high resolution, and sharpness come at a cost: wafer-thin depth-of-field. You must make sure your focus is exactly where you want it.

Is that the final word for Zeiss? Not quite. There are two products I'd like to mention, one looking back and the other forward. The first are Zeiss fire doors! Yes, believe it or not, but Zeiss made fire doors, or more specifically, fire shutters, for cinema projection booths that used heat fuses to partition the booth if it caught fire, a potential problem with old nitrate film stock. It's an example of how a large business can expand both horizontally (manufacturing projectors) and vertically (manufacturing related equipment for the booth).

The second is the Zeiss ZX1 digital camera. Zeiss has re-entered the camera market. First announced at Photokina in September 2018, it took 2 years to actually hit the shops. In a design simi-

lar to the Leica Q2 and Sony RX1R (with a Zeiss Sonnar lens), this is a full-frame 37 MP camera with fixed f/2 35mm Distagon lens. However, what marks it as different is the internal 512GB SSD and built-in Lightroom Mobile for raw image editing. This is a one-off camera, possibly a live prototype to test the market, that is built to the highest standards. Can it leverage the processing power of computational photography within a fully blown camera rather than a smartphone? Whatever the future holds, it is a good demonstration of how Zeiss uses research and development to remain a market leader.

Image copyright Zeiss

EMILE ZOLA

The famed French novelist Emile Zola was born in 1840 and in 1862, began his working life as an admin clerk at the publishers L.C.F. Hachette. To supplement his income, he wrote articles on contemporary interests for a range of journals while continuing to write fiction. His first novel was published in 1865 and garnered enough attention for him to support himself through his writing. It was in 1868 that he formulated the Rougon-Macquart Series, ten books (gradually expanded to 20) based around members from two branches of the same family, one respectable and the other disreputable. Set in France's Second Empire, it viscerally details the impacts of industrialisation upon the individual lives of his characters.

In 1880, he founded the naturalist movement — no, not that kind of naturalism — rather, literary naturalism that is based around realism (the characters and setting should be realistic), that conflict in the story should be life-altering, and the plot be simple. Driven by the tenets of the natural sciences, its main principles were determinism (characters were a product of their history and environment) and the scientific method (objectively recording the detail). On this premise, the novelist could explore his characters in detail.

So, what has this got to do with photography? Perhaps unsurprisingly, given his naturalist underpinnings, he was interested in realism and objective recordings, something that photography directly addressed. He began to practice in 1894 (after the completion of the Rougon-Macquart series), and over the remaining seven years of his life, produced somewhere in the region of 7,000 glass plates using 10 different cameras, devel-

oping them himself in darkrooms he had installed in his three homes. As a result, he became a skilled darkroom technician. His subjects were diverse: his family (his wife, mistress, and two children), his brief exile to England (during the Dreyfus Affair, where he was convicted of criminal libel), Paris life, the 1900 Exposition Universelle (with many taken from the Eiffel Tower), self-portraits, architecture, and landscapes.

Given the extent of the archive and copious notes detailing his experimentation with exposure, development, and printing, he became a quasi-professional during a period when photography required time and dedication to be proficient. Lewis Carroll was similarly enthralled with photography, and so it's possible that where authors intersect with the scientific method, there is an innate interest in practices such as photography. Zola therefore takes a deserved place in the pantheon of photography and concludes the A to Z!

<p style="text-align:center">* * *</p>

Beyond The Cut

Other Zs that didn't make the very last letter include Zenit, Zorki, Zuiko, zone system, zoom, and zoom burst effect.

Printed in Great Britain
by Amazon